IMAGES
of America

CINCINNATI CHILDREN'S
HOSPITAL MEDICAL CENTER

D0872469

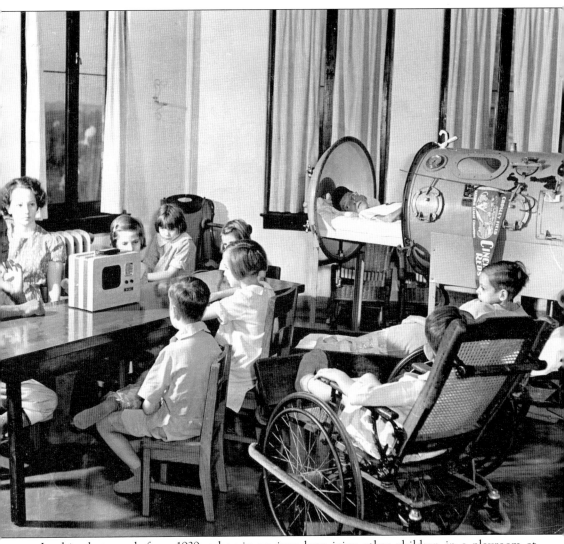

In this photograph from 1939, a boy in an iron lung joins other children in a playroom at Cincinnati Children's Hospital Medical Center. Iron lungs were respirators used to treat patients with severe lung disease due to polio. The pennant flags on the iron lung give a clue as to why the children are listening so intently to the radio. The Cincinnati Reds were the 1939 National League champions, and the children are listening to a World Series game. The year 1939 was momentous in another way for the story of Cincinnati Children's: Albert Sabin, M.D., arrived in Cincinnati that year. The oral polio vaccine he developed in the research laboratories at Cincinnati Children's would conquer polio around the world, protecting countless children from the ravages of that dread disease.

On the cover: Please see above. (Courtesy of the Cincinnati Children's Hospital Medical Center.)

IMAGES
of America

CINCINNATI CHILDREN'S HOSPITAL MEDICAL CENTER

Beatrice Katz, Ph.D., Editor

ARCADIA
PUBLISHING

Published by Arcadia Publishing
Charleston SC, Chicago IL, Portsmouth NH, San Francisco CA

Printed in the United States of America

Library of Congress Catalog Card Number: 2008927845

For all general information contact Arcadia Publishing at:
Telephone 843-853-2070
Fax 843-853-0044
E-mail sales@arcadiapublishing.com
For customer service and orders:
Toll-Free 1-888-313-2665

Visit us on the Internet at www.arcadiapublishing.com

To the children, our most precious resource

CONTENTS

ACKNOWLEDGMENTS

I thought I knew a lot about Cincinnati Children's when I started working on this book, but oh, how much I have learned about its rich history over the months spent digging through photograph archives, reading old publications, and consulting with colleagues. As I write the final words, I feel greater respect than ever for this remarkable institution, and especially for the talented, visionary people whose work here, at every stage of the hospital's 125-year history, contributed so much to the lives of children everywhere.

When it was formed in 1883, Cincinnati Children's was one of the first hospitals for children in the country. When it opened the Children's Hospital Research Foundation in 1931, it was the first pediatric hospital in the United States to have a building dedicated to research. When it embraced the challenge of making transformational change in 2001, it became a model for children's hospitals across the country. In short, Cincinnati Children's has often been at the forefront of advances in pediatric health care.

The 195 photographs and detailed history in the following pages tell part of the story. Inevitably, there is far more to tell than can fit within the covers of this slim volume, especially about the contemporary era. The editorial committee hopes that readers will enjoy and learn from what is here, and forgive the omissions.

Special thanks are due to Carrie Schmitt Harrison, who first suggested the project, and to the editorial committee members, whose years of service to Cincinnati Children's and long memory made them invaluable resources: William Schubert, M.D.; Michael Farrell, M.D.; William Gerhardt, M.D.; Paul McEnery, M.D.; Anne Longo, R.N.; Claire Kessler; and Chaplain Bill Scrivener. Thanks, as well, to the many people who volunteered to help, answered questions, and offered suggestions.

To my colleagues in the Marketing and Communications Department, and, of course, to my amazingly supportive husband, Marc Katz, thank you for your encouragement throughout this project.

Beatrice Katz, Ph.D.
Editor

INTRODUCTION

Cincinnati Children's Hospital Medical Center celebrates its 125th anniversary in 2008. The women who first proposed opening a hospital for children in 1883 would be astonished at the institution it has become: one of the largest, most respected children's hospitals in the United States; a comprehensive care center for families throughout Greater Cincinnati; an international referral center for children with the most complex diseases; a global leader in pediatric research; an educational mecca for health care and research professionals; and the fastest growing business in southwest Ohio, with more than 10,000 employees and an annual operating budget of over $1 billion.

Yet from its modest beginnings in a small house in Walnut Hills to its international stature today, the goal of Cincinnati Children's has remained constant: to deliver the best medical and quality of life outcomes, experiences for children and their families, and value.

Cincinnati Children's began as the Protestant Episcopal Hospital. The impetus came from one civic-minded Episcopal woman who was concerned about conditions for children in the city's hospitals, where children were housed with adult patients, and the mortality rate was high. She and her friends won the support of the bishop of the Episcopal Diocese of Southern Ohio. Their dream of a hospital especially for children became a reality when incorporation papers were signed on November 16, 1883. The hospital opened in a rented house in March 1884.

Small as it was, this hospital was in the vanguard of a new movement to focus on the needs of children. The practice of pediatrics as a medical specialty began to emerge in the 1850s. The first hospital for children in the United States opened in Philadelphia in 1855. A professorship of pediatrics was established at the New York Medical School in 1860, and a pediatric clinic was introduced in 1862.

Cincinnati was not far behind. Frederick Forchheimer, M.D., was appointed professor of physiology and clinical diseases of children at the Ohio Medical College in 1879. He opened a children's clinic a year later. By 1884, Cincinnati had its own children's hospital, which took pride in providing nutritious food and pure air, the best medical and surgical treatment, and the tenderest care.

Through the years, Cincinnati Children's and the field of pediatric medicine grew together, and a series of visionary leaders set the course for the hospital to become the leader in improving child health.

The first expansion came when J. Josiah and Thomas J. Emery donated an acre of land near the Christ Hospital and constructed a brick building for a larger hospital. The building opened on November 23, 1887, with 20 beds ready for use and room for another 20. A nurse training school was added in 1906. By 1919, the hospital had expanded to 90 beds, and the community's doctors were asking for more.

Meanwhile, in 1908 the Ohio Medical College had merged with the Miami Medical College to form the Medical College of the University of Cincinnati. A new building for the college opened in 1918, near the 1909 General Hospital (now University Hospital) on the hilltop in Avondale. In addition to building new facilities, the college was building a highly skilled faculty by creating full-time professorships. The first was in physiology in 1910, followed by bacteriology, pathology, medicine, chemistry, pharmacy, and surgery. In 1920, Mary Emery endowed a professorship of pediatrics, in honor of Benjamin Knox Rachford, M.D., the first doctor in the community to restrict his practice to children.

In this dynamic medical environment, two leaders emerged at the Protestant Episcopal Hospital who would profoundly shape its future: William Cooper Procter, who was elected president of the board of trustees in 1921, and Albert Graeme Mitchell, M.D., who was recruited as the B. K. Rachford Professor of Pediatrics in 1923.

Guided by Procter and Dr. Mitchell, Cincinnati Children's built a state-of-the-art hospital that increased patient beds from 90 to 200, established an academic affiliation with the University of Cincinnati to serve as the Department of Pediatrics in the College of Medicine, became accredited as a site for pediatric residency training, established a research program, became the nation's first pediatric hospital to have a building specifically devoted to research, and recruited physicians and researchers who changed pediatric medicine in Cincinnati and around the world.

Two of the scientists who made the most significant contributions ever to come from the labs at Cincinnati Children's—Josef Warkany, M.D., and Albert Sabin, M.D.—were hired in the first decade after the research foundation opened its doors in 1931.

Procter died in 1934. Dr. Mitchell died in 1941. The passing of these giants marked the end of an era, but they left behind an institution poised for greatness.

As the specialty of pediatrics developed, Cincinnati Children's was often on the leading edge: the first to perform open-heart surgery, using a heart-lung bypass machine perfected here; a pioneer in the study of nutritional and environmental factors that cause birth defects; the second hospital to establish a pediatric gastroenterology department; the second children's hospital to have a full-time recreation department for care of the whole child; the first kidney transplant in Ohio; one of the first hospitals in the world to perform segmental liver transplant; life-saving advances in the care of lung disease in premature infants; a leader in vaccine development, from the Sabin oral polio vaccine to the newly FDA-approved rotavirus vaccine; a national model for transformational quality improvement—the list of accomplishments goes on and on.

This book traces the 125-year history of Cincinnati Children's in pictures and words. The hospital's photograph archives provided a treasure-trove of images to tell the story. In these pages are historical photographs of many of the men and women, clinicians and scientists, and volunteers and donors who helped make history at Cincinnati Children's. And above all, there are pictures of the children. For many readers, these will be the most touching images—as they should be, since ultimately, they are what the hospital, and therefore this book, are about.

As the photographs show, patients at Cincinnati Children's are not simply defined by their illness. They are children who need to play and learn, celebrate birthdays and holidays—be kids, on their way to becoming productive adults. In a speech just a few weeks before his death, Dr. Mitchell put it this way: "We think in terms of the entire child and his place in the family and the community, and his present and future contributions to society. To do less—to think only of the disease or defect—would be to perform an incomplete job for the child." To show this side of the hospital's history, this book devotes a chapter to the theme "Play, the Vital Work of Childhood."

Over the last decade, Cincinnati Children's has experienced exponential growth in facilities, employees, clinical services, and research programs. The concluding chapter, "A Vision for the Future," begins to explore these accomplishments. In truth, it would take a vastly larger book to document the full scope of Cincinnati Children's today. Suffice it to say that our children have access to an unprecedented level of care, and families around the country and the world now come to Cincinnati for services not available to them in their home communities.

One

THE EARLY YEARS

The idea of opening a children's hospital in Cincinnati began with one woman, Mrs. Robert Dayton. Throughout 1883, she discussed her idea for a charity hospital for the city's poor children with Isabelle Hopkins, Mary Emery (Isabelle's sister), their women friends in the Episcopal diocese, and their bishop, Thomas Jaggar.

By fall, plans were taking shape. Incorporation papers for the Protestant Episcopal Hospital were signed on November 16, 1883. Bishop Jaggar was named president of the board of trustees, and a board of lady managers was created to oversee day-to-day operations.

By mid-December, the trustees had rented a three-bedroom house in Walnut Hills, and on January 1, 1884, the diocese rallied to the hospital's support with donations of food, clothing, toys, furniture, money, and other necessities.

After months of work putting the house in order, the hospital opened in March 1884. It served 38 children in its first year. Four volunteer doctors, a nurse, a housemother, and volunteers cared for the children. Children were admitted without regard to race or religion. All care was free.

Although the hospital took pride in offering the best and tenderest care, the small house was inadequate. Board minutes noted that the house "affords only three small bedrooms . . . has but one small bathroom, an insufficiency of hot water, and miserable, worn out heating apparatus." There was no operating room, so that "the little ones witness the preparation for an ordeal to which they may be looking forward later on."

Two generous contributors came to the rescue. J. Josiah and Thomas J. Emery donated land near the Christ Hospital in Mount Auburn and built a three-story brick hospital. It opened in November 1887 with 20 beds, and by 1919 had expanded to 90.

By 1920, the hospital was admitting private as well as charity patients. Their payments helped ease the financial burden of running a charity hospital, and the head of the medical staff was pleased that "the patient does not have to be of the charity class in order to have the advantages which this Hospital offers for treatment."

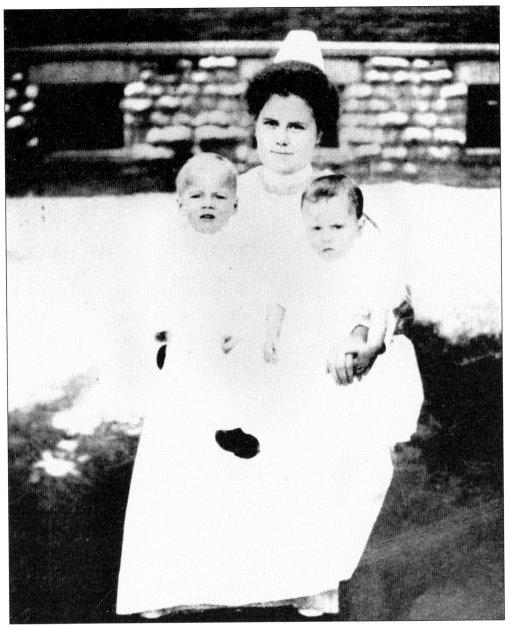

A nurse takes two of her patients outdoors for fresh air. In the hospital's early years, there was limited medicine as it is known today. The keys to recovery were nutrition, clean water, sunlight, and rest. Hospital stays were long, as much as 90 days for draining an ear.

Approached by women advocating for a children's hospital, Bishop Thomas Jaggar supported the idea of establishing the hospital as a project of the Episcopal Diocese of Southern Ohio. Incorporation papers for the Protestant Episcopal Hospital were signed on November 16, 1883. Bishop Jaggar was elected president of the board of trustees.

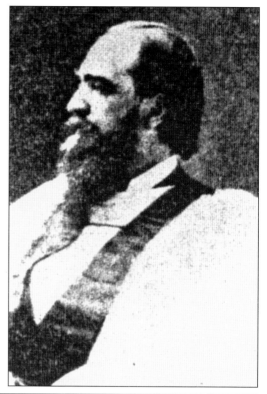

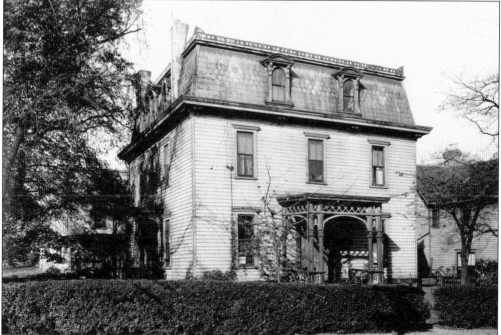

By mid-December, the trustees had found a home for the hospital—a three-bedroom house at the corner of Park and Yale Avenues in Walnut Hills. After several months of preparation, the hospital opened in March 1884. It admitted 38 patients in its first year. The house still stands.

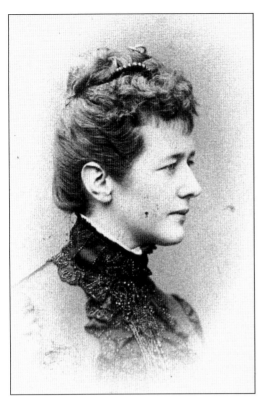

At the founding of the hospital, two boards were created, the board of trustees and the board of lady managers, which was responsible for day-to-day management of the hospital. Mrs. Alexander McGuffey was the first president of the lady managers. Pictured here is Mrs. Henry Probasco, president from about 1894 to 1904.

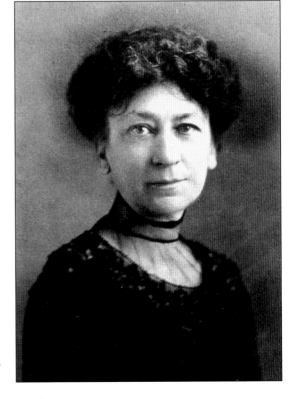

On January 16, 1884, the Cooperative Committee, comprised of women representing the parishes in the diocese, met to plan activities to support the hospital. Mrs. T. H. C. Allen was elected president. Pictured here is Isabelle Pogue Eastman, wife of George Eastman, one of the founding members and a longtime president. Now known as the Cooperative Society, the group still raises funds for Cincinnati Children's.

J. Josiah Emery (right) and his brother
Thomas J. (below), sons of the founder
of Emery Industries, came to the rescue
when it became clear the hospital needed
larger, better-equipped facilities. They
bought an acre of land and constructed a
three-story brick building.

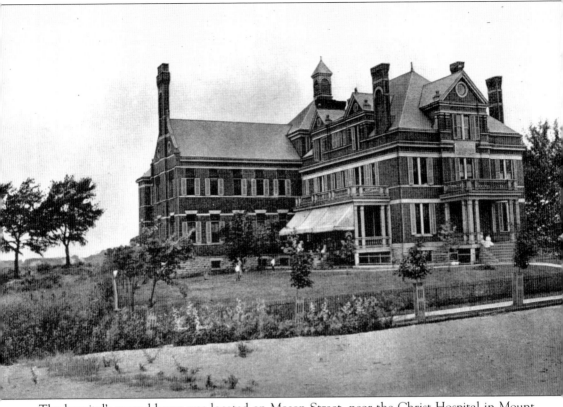

The hospital's second home was located on Mason Street, near the Christ Hospital in Mount Auburn. It opened on November 23, 1887, with 20 beds on two wards. Two additional wards were to be completed within two months. The number of patients admitted increased from 48 to 151 in the first year. Another wing was added to the hospital in 1904. It featured a playroom and chapel on the first floor and a ward for children with contagious diseases on the second floor.

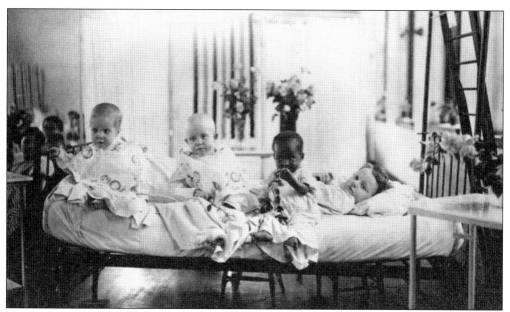

The hospital provided free care for the poor children of Cincinnati. As this picture from 1897 demonstrates, children were admitted without regard to race, creed, or color.

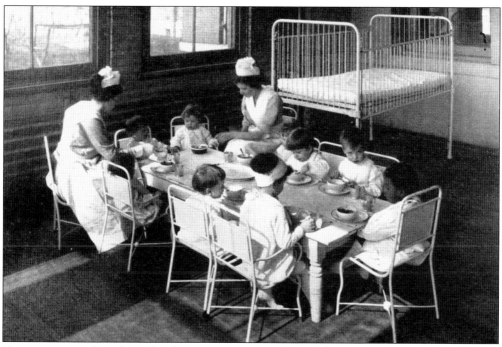

Nurses supervised mealtime for their young patients. One of the missions of the hospital was to provide a family atmosphere at mealtime. From breakfast, the children went to the classroom, where governess A. Eliza Gordon, hired in 1889, taught reading, spelling, writing, arithmetic, language, and composition. The lady managers recognized that the classroom offered both "educational advantages" and "welcome relief" from the monotonous life of a child in the hospital.

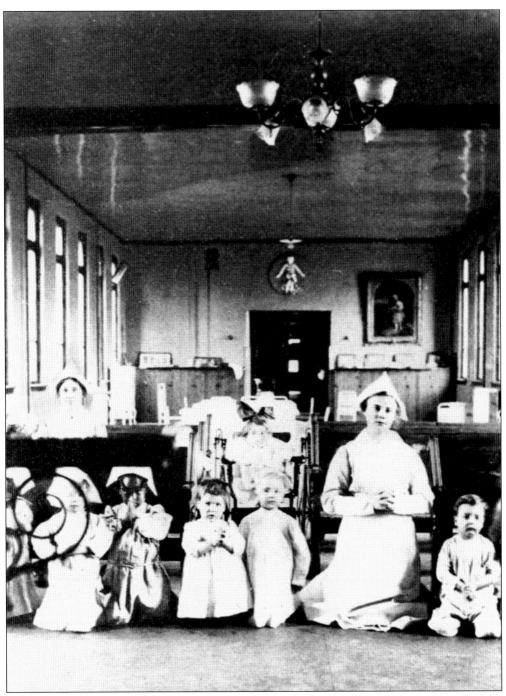

In this picture from 1914, a nurse prays with her young patients in the hospital's Chapel of the Holy Child. Daily prayer was encouraged, but one of the hospital's earliest annual reports noted, "We do not force any form of worship upon those who come to us, perfect liberty being granted, and respect paid to the faith of those who entrust their children to our care." Note the medallion on the back wall. The figure of a baby in swaddling clothes was the hospital's unofficial logo for many years.

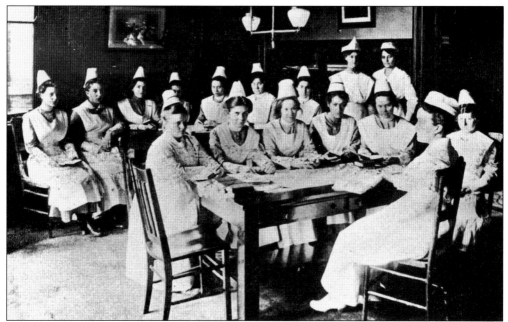

The 1904 expansion of the hospital heightened the need for qualified nurses. The hospital opened its own nurse training school in 1906. In 1915, the course of training was lengthened from 18 months to two years, to include three months in the Obstetrics Department at Bethesda Hospital and three months in the Contagious Disease Hospital at the General Hospital. This scene is from about 1916.

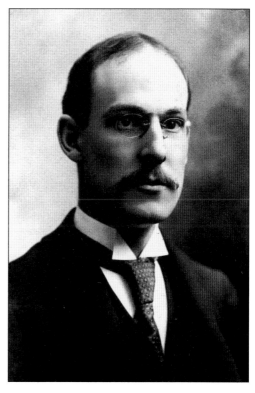

Arch Carson, M.D., surgeon, was president of the medical staff from about 1908 to 1914.

Mary Emery, one of Cincinnati's great philanthropists, gave many gifts to advance medical care. When a new medical college was being planned, she contributed $250,000 for the building's construction and expressed interest in endowing the pediatrics chair, which was held by her friend Benjamin Knox Rachford, M.D. He persuaded her to support a professorship in pathology instead. In 1920, when Dr. Rachford was stepping down, Emery endowed the pediatrics chair in his honor. Kenneth Blackfan, M.D., was chosen as the first B. K. Rachford Professor of Pediatrics in 1920. He moved to Boston in 1923.

Two

AN EXPANDING MISSION

The 1920s brought dramatic changes. By the end of the decade, the hospital had a new name, a new home, and a greatly expanded mission to provide patient care, education, and research.

For its first 38 years, the hospital was run by a board of trustees and a board of lady managers, which had to agree on every decision. This structure was reorganized in 1921. The board of lady managers was dissolved, and a new board of trustees was established. One of its first actions was to change the hospital's name to the Children's Hospital.

William Cooper Procter, president of P&G and grandson of its cofounder, was elected president of the board. Until his death in 1934, Procter devoted extraordinary energy and resources to the Children's Hospital.

There had been talk about adding a pavilion to expand the hospital. Procter, however, had bigger ideas. He believed a new hospital should be built near the University of Cincinnati College of Medicine and should be affiliated with it. After winning approval from the board and raising over $1 million, Procter bought land and selected an architect.

Responsibility for planning the hospital came to rest on the capable shoulders of Albert Graeme Mitchell, M.D., who arrived in Cincinnati in the summer of 1924 as the second B. K. Rachford Professor of Pediatrics. Procter relied on Dr. Mitchell to design the building, organize the staff, and work out the relationship with the college. By the time the building was completed, Dr. Mitchell was ready. The 200-bed hospital opened to national acclaim on December 6, 1926.

Behind the scenes, Dr. Mitchell tirelessly advocated for more. In a letter to the board, he argued that "unless effort is made to study and investigate problems in a manner which will add in a constructive way to existing knowledge, we have all of us failed to function to the fullest extent."

Procter responded with a breathtaking gift of $2.5 million to build and endow the Children's Hospital Research Foundation. When the research foundation opened in 1931, Cincinnati Children's became the first pediatric hospital in the country to have a building dedicated solely to research.

William Cooper Procter, grandson of the cofounder of P&G and company president since 1907, joined the hospital's board of trustees in 1913. When the hospital's governing structure was reorganized in 1921, he was elected president of the new board of trustees, a position he held until his death in 1934. Procter's extraordinary leadership and philanthropy resulted in dramatic expansion in the hospital's size, scope, mission, and reputation. One of the first acts of his new board was to change the hospital's name from the Protestant Episcopal Hospital to the Children's Hospital.

Albert Graeme Mitchell, M.D., arrived in Cincinnati as the second B. K. Rachford Professor of Pediatrics in the summer of 1924. His responsibilities included teaching medical students and caring for children admitted to the General Hospital. Procter had purchased land near the medical college for a new children's hospital in 1923. He relied on Dr. Mitchell to plan the building and recruit the staff needed for a much larger hospital. Procter also was determined that the hospital's medical staff be affiliated with the medical college. Dr. Mitchell worked out the affiliation. Since 1926, Cincinnati Children's has comprised the Department of Pediatrics of the University of Cincinnati College of Medicine. Dr. Mitchell was the first to be both B. K. Rachford Professor of Pediatrics, chairing the Department of Pediatrics, and physician-in-chief of the Children's Hospital, a tradition that continues to the present day. He advocated for establishing the Children's Hospital Research Foundation, and he edited the second through fifth editions of the *Textbook of Pediatrics*, the most influential textbook in the field.

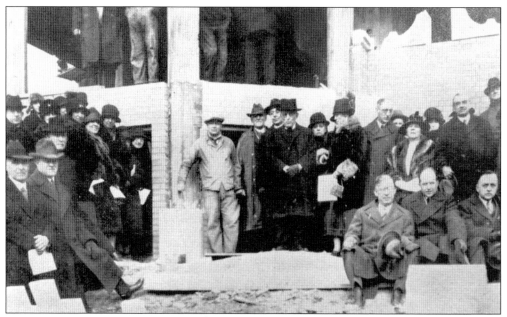

The cornerstone for the new children's hospital was laid in December 1925. William Cooper Procter, wearing a black coat and tall hat, is standing in the center. Dr. Albert Graeme Mitchell is seated second from the right. Years after the building opened, the dean of the College of Medicine recalled Dr. Mitchell looking over blueprints and declaring, "We'll have something here. There'll be nothing like it in the world."

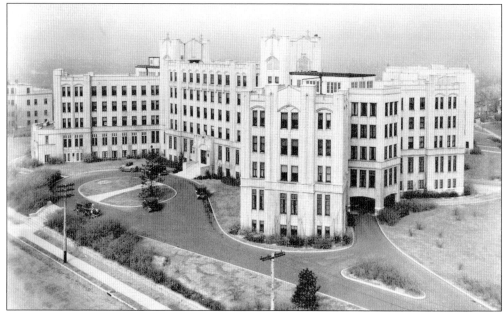

The first patients moved into the new hospital on December 6, 1926. The building was praised locally, nationally, and even internationally. A biologist from Japan who had visited was asked in his home country what was the most inspiring thing he had seen in America. His answer was, "the Children's Hospital in Cincinnati." He encouraged his countrymen not to be satisfied until they could point to a hospital that was as carefully planned and beautifully executed.

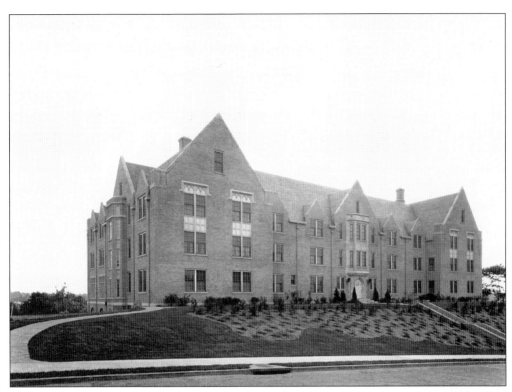

The second building on the hospital's campus was a residence for the nursing school, financed by William Cooper Procter. The building opened in 1928. It was named Vincent Hall in honor of Episcopal bishop Boyd Vincent (right), second president of the hospital's board of trustees, from about 1905 to 1921. The nursing school was closed and the building was demolished in 1978.

Inside Vincent Hall, nurses socialized when they were not busy in the hospital. The original building had 72 bedrooms. A wing was added in the 1930s. It is estimated that 20,000 graduate and nursing students lived in Vincent Hall over the years.

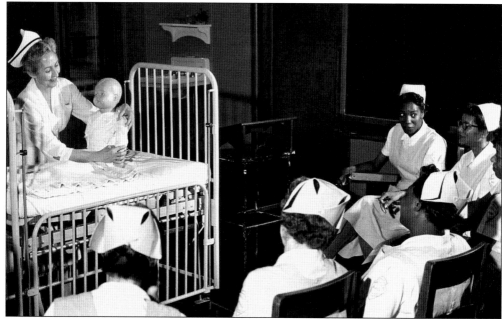

Nursing education included proper positioning of the patient for such things as feeding and postoperative care. Nurses came to class in starched uniforms and nursing caps. Notice the stripe on the instructor's cap. The students have not yet earned their stripe. Today instead of using dolls, trainers at Cincinnati Children's use computerized human simulators to provide highly realistic training experiences for nurses, physicians, emergency squads, and others.

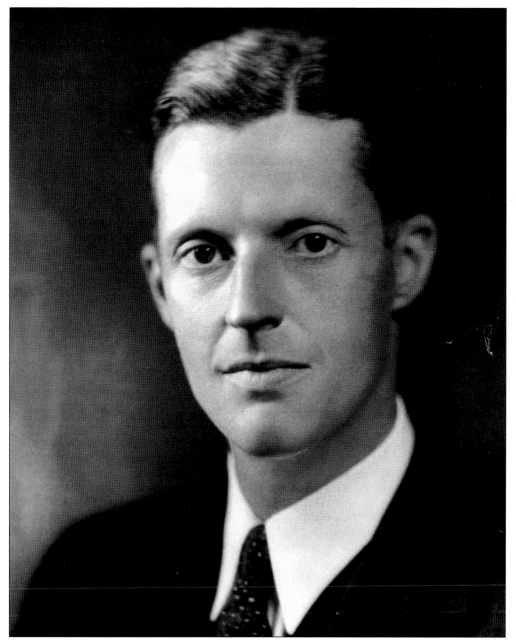

The Department of Pediatrics was responsible for patients at the General Hospital, the Contagious Disease Hospital, the Children's Hospital, and the Convalescent Hospital for Children. To build the staff, Dr. Albert Graeme Mitchell began recruiting from the interns and residents he trained. His first full-time appointment was Frank Stevenson, M.D., in 1926. The next year he hired Robert Lyon, M.D., pictured here, as his second full-time appointment. Dr. Lyon became one of the most important contributors to pediatric health care in Cincinnati. With Louise Rauh, M.D., he established cardiac clinics at the General Hospital and Children's Hospital, the newborn service, the Children's Heart Association, the Children's Dental Care Foundation, and the Adolescent Clinic.

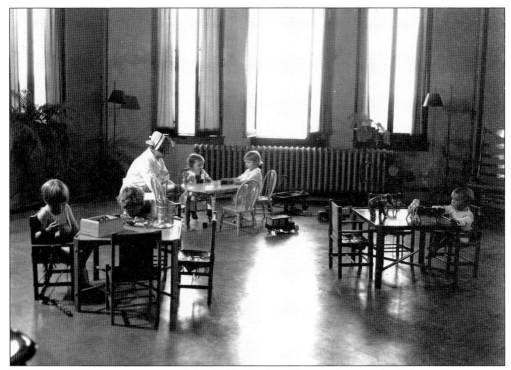

Playtime was an important part of the children's day. The new hospital had playrooms on every floor and solariums behind the nurses' station to allow for oversight of the children as they played. This picture shows the Anderson solarium around 1930.

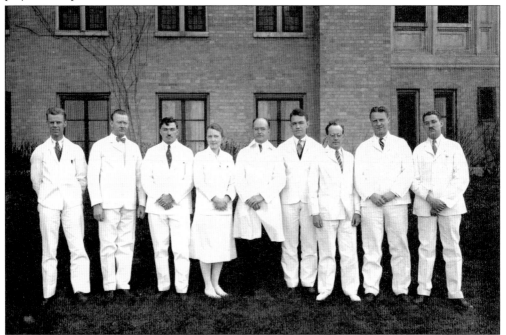

Dr. Albert Graeme Mitchell, center, is surrounded by pediatric residents in the class of 1928–1929. The sole woman in the class was Faith Williams Bell, M.D.

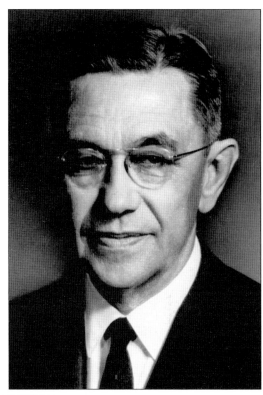

Dr. Albert Graeme Mitchell's third full-time appointment was Waldo Nelson, M.D. With his skill in administration and organization, Dr. Nelson played a critical role in developing the expanding hospital. He moved to Philadelphia in 1940 as chairman of the Department of Pediatrics at St. Christopher's Children's Hospital. After Dr. Mitchell's death in 1941, Dr. Nelson took over the role of editor of the *Textbook of Pediatrics*, serving as editor through the 11th edition. Cincinnati Children's faculty have always contributed to this textbook, which is one of the two major texts in pediatrics, even today. Below, in December 1995, when he was 97, Dr. Nelson returned to Cincinnati Children's for the dedication of the Mitchell-Nelson Physician Lounge and History Library.

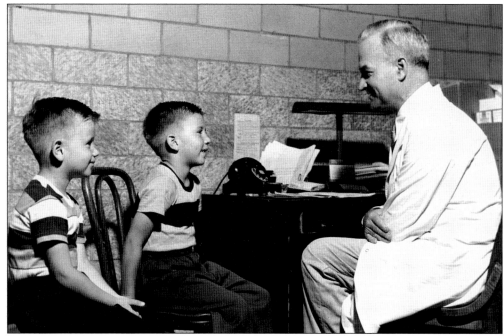

George Guest, M.D., who Dr. Albert Graeme Mitchell recruited in 1928 as director of the Children's Hospital Research Foundation, helped plan the new research building. He also was director of the diabetes clinic.

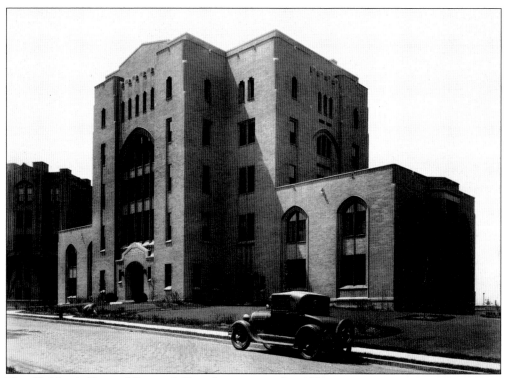

The Children's Hospital Research Foundation opened in 1931.

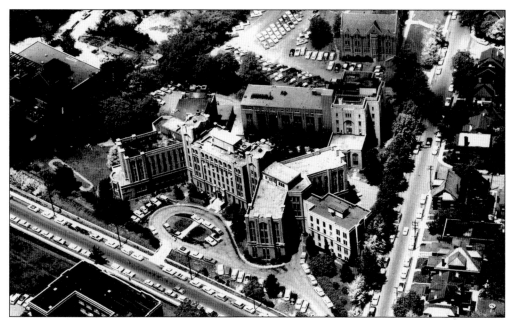

In this aerial photograph, one can see the 1926 hospital in the foreground, the adjacent research building, and the nurses' residence.

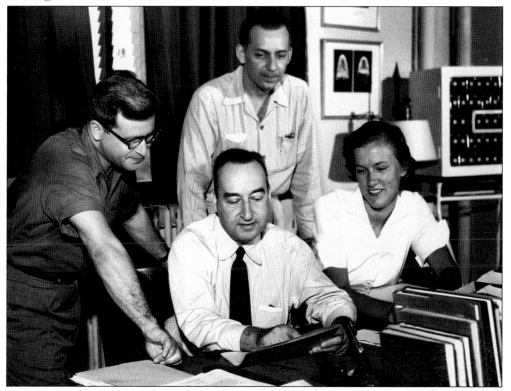

Among the first to join the new research foundation was Josef Warkany, M.D. (center), who arrived from Vienna on January 1, 1932, for a one-year fellowship. He ended up spending his entire career at Cincinnati Children's.

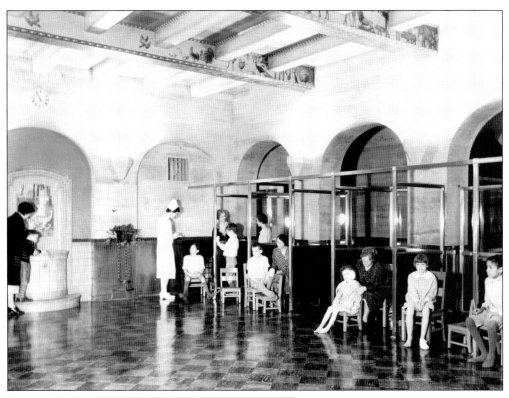

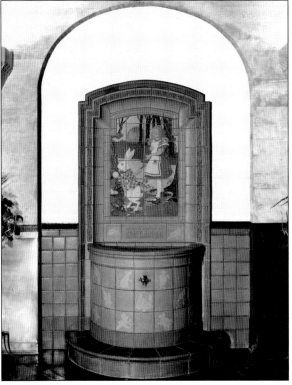

The hospital's outpatient clinic was located on the first floor of the research foundation building. As these photographs show, the clinic was beautifully decorated with coffered ceilings, murals, and a Rookwood tile fountain with an Alice in Wonderland theme.

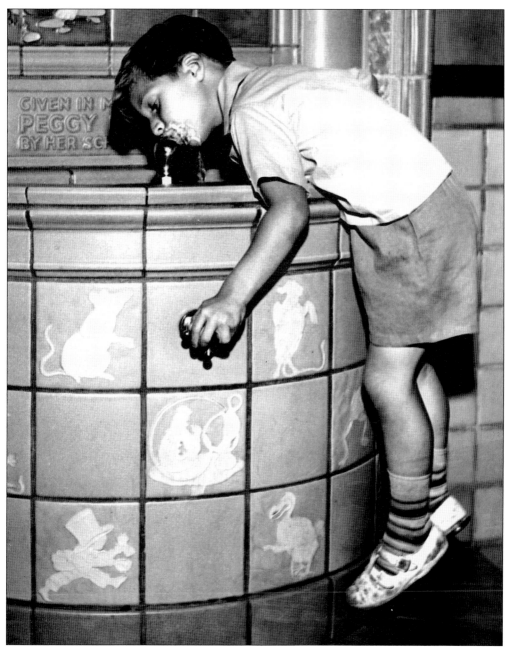

This youngster is getting a good drink.

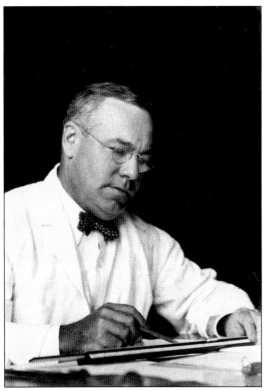

Biochemist Glenn Cullen, Ph.D., joined the Children's Hospital Research Foundation on July 1, 1931. He went on to become president of the American Chemical Society and the first nonphysician elected to the American Pediatric Society.

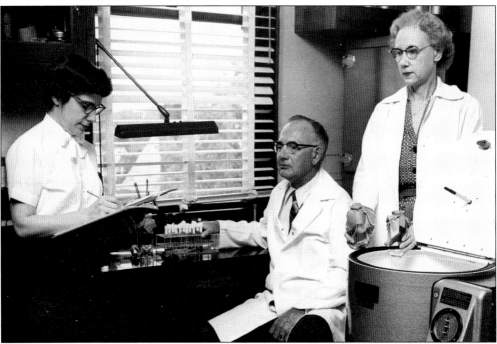

The second research division Dr. Albert Graeme Mitchell established was bacteriology. He selected Merlin Cooper, M.D., as director. Dr. Cooper organized the bacteriology labs in the new research foundation and did extensive research on immunization against dysentery.

Three

DECADES OF GROWTH AND CHANGE

By 1932, Cincinnati Children's had made the leap into national prominence. The hospital had enviable patient care and research facilities and a growing staff. It was guided by a dynamic leader, who was a clinician, researcher, teacher, author, and oft-sought lecturer.

The decades ahead would bring steady evolution in the field of pediatric medicine and increasing recognition for Cincinnati Children's as a leader.

When Dr. Mitchell died in 1941, A. Ashley Weech, M.D., became the Rachford Professor of Pediatrics (1942–1963). During his tenure, pediatric medicine became more specialized. Dr. Weech recruited outstanding pediatric subspecialists, still called "the dream team" by those who remember their contributions to patient care, research, and education.

The world's first functional heart-lung machine was perfected in the research foundation in the early 1950s to permit successful open-heart surgery. Albert Sabin, M.D., developed a safe oral polio vaccine in the late 1950s that dramatically halted that dread disease nationally and in most countries around the world.

In the 1970s, under the leadership of Edward Pratt, M.D., pediatric care in Greater Cincinnati was centralized at Cincinnati Children's. The Convalescent Hospital, Adolescent Clinic, Cerebral Palsy Services Center, Dental Care Foundation, and Cincinnati Center for Developmental Disorders moved to the hospital campus in 1973. By 1976, General, Good Samaritan, and Jewish Hospitals had closed their pediatric wards and moved their pediatric residency programs to Cincinnati Children's. At the close of the decade, Greater Cincinnati had a unique regionalized system of pediatric care, with comprehensive services in one location.

In the 1980s, the pace of change accelerated as pediatric medicine grew ever more specialized, and new molecular genetics research techniques revolutionized biomedical research. Under the leadership of William Schubert, M.D., Cincinnati Children's added clinical divisions and research programs and recruited world-class staff. Physical facilities were expanded, with a new hospital and research building and outpatient centers in Cincinnati's growing suburbs.

This chapter introduces some of the many people who contributed to the medical center's development. Their work, and the collaboration of bedside care and research teams, has had a far-reaching impact on the life of millions of children everywhere.

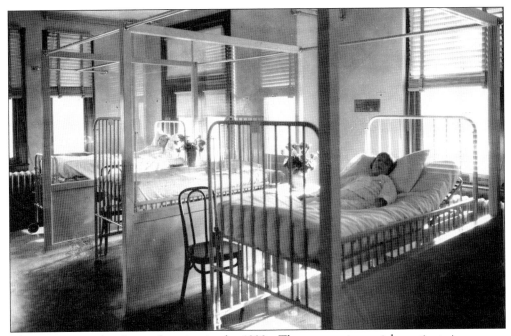

This is an example of a ward setting in the 1930s. There were six to eight patients in a room, separated by glass. There was just a chair for parents. Typically, patients were grouped by diagnosis. Today patients have private rooms, with bathrooms. Pull-out couches allow parents to spend the night comfortably.

An asylum for orphans was opened in Cincinnati in 1832. By 1930, orphans were being placed in foster homes rather than institutions, and the orphanage was becoming obsolete. Albert Graeme Mitchell, M.D., persuaded the board to address a greater community need by building a hospital for the care and rehabilitation of chronically ill children on the orphanage site in Mount Auburn. The Convalescent Hospital for Children opened in 1931. Dr. Mitchell appointed Waldo Nelson, M.D., to direct the medical care.

Louise Rauh, M.D., and Robert Lyon, M.D., introduced a cardiac service for children at the General Hospital in 1931 and at the Children's Hospital in 1939. Here, Dr. Rauh examines a child in the cardiology clinic at Children's Hospital.

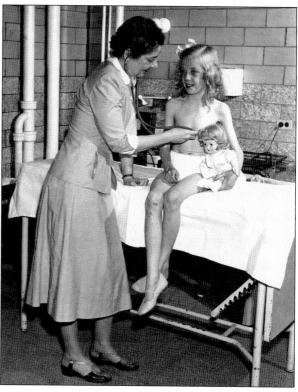

Samuel Rapoport, M.D., came from Vienna to join the Children's Hospital Research Foundation in 1937. During World War II, he perfected a preservative solution for whole blood, which was used by the U.S. Army and Navy, for which he was awarded a Presidential Certificate of Merit. Despite this service to his country, he became a target of Sen. Joseph McCarthy's Un-American Activities Committee for his involvement with the American Communist Party. He fled the country in 1952 and settled in East Germany, where he became a leader in pediatric research. His wife, Ingeborg Syllm Rapoport, M.D., who did her pediatric residency at Cincinnati Children's, founded the specialty of neonatology in East Germany.

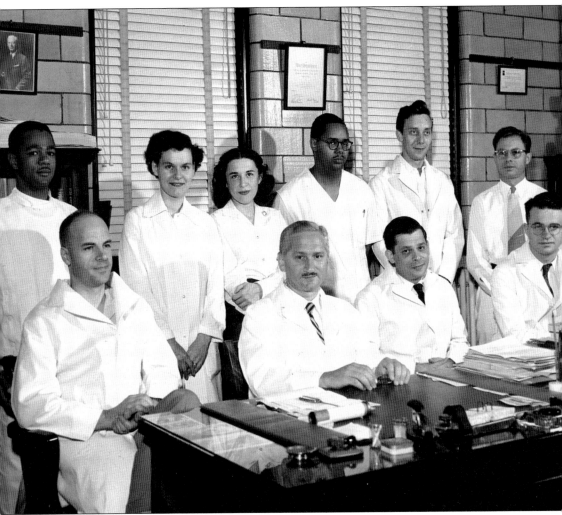

Albert Sabin, M.D., joined the research foundation in 1939. Here Dr. Sabin, seated center, is surrounded by three virology fellows (seated) and his research laboratory staff. Dr. Sabin spent 30 years working at Cincinnati Children's. By the late 1950s, he had perfected the oral polio vaccine, which was first tested in Russia and other countries. By the time the U.S. Public Health Service gave approval for testing, 80 million people outside the United States had taken the vaccine.

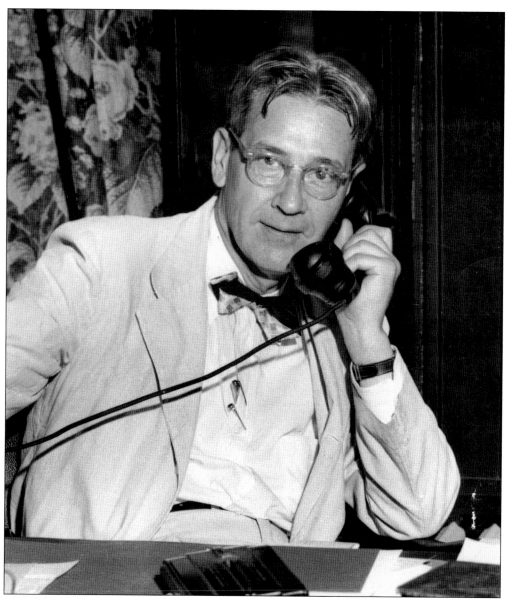

A. Ashley Weech, M.D., accepted the position of chairman of the Department of Pediatrics on December 7, 1941, the same day Pearl Harbor was attacked. He arrived in Cincinnati in 1942. Many of Cincinnati Children's physicians and researchers were called into the armed forces during the war years. After World War II ended, Dr. Weech rebuilt and expanded the faculty. As new subspecialities of pediatrics became established in the 1950s, Dr. Weech hired outstanding directors for new pediatric divisions: the Divisions of Child Psychiatry, Radiology, Cardiology, Physiological Chemistry (now Nephrology), Surgery, Hematology, and Pathology. He retired in 1963. For the next 10 years, he served as editor of the *American Journal of Diseases of Children*.

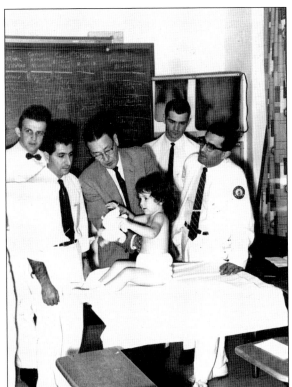

With many hospital staff called to military service, Dr. Weech did much of the teaching. He was known for breaking into song to calm a child in distress. Dr. Weech believed that in the academic environment, "diagnostic acumen is constantly being prodded toward excellence," and the link with research attracts young physicians "whose curiosity can be stirred by the challenge of unsolved problems."

Katherine (Katie) Dodd, M.D. (right foreground), was Dr. Weech's first full-time appointment in 1943. He had known her since medical school. Even today she is remembered as the best clinical teacher in the history of Cincinnati Children's. She was often accompanied on rounds by community pediatricians, as well as residents. She left in 1952 to become the first woman chair of a Department of Pediatrics in the country, at Children's Hospital of Arkansas.

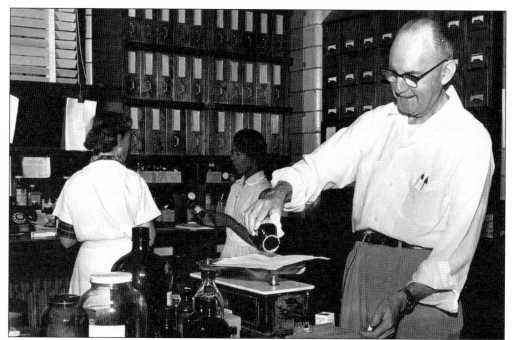

Gus Reif, seen here weighing out medicine, was chief pharmacist in the 1940s. In today's pharmacy at Cincinnati Children's, a robotic device compounds medicines more quickly and accurately than ever before. The number of medications available has dramatically increased since the 1940s, as have the educational requirements for pharmacists. Today many pharmacists at Cincinnati Children's have doctoral degrees and complete a residency before practicing at the hospital.

Louise Flynn, R.N., began nursing at Cincinnati Children's in 1934 as a graduate student. She was appointed director of nursing education of the hospital's School of Nursing in 1942, and was director of nursing from 1948 to 1974. Among her accomplishments, she introduced the concept of orienting new nurses to the nursing units and initiated the preoperative education program to prepare children and parents for surgery. Both programs continue today.

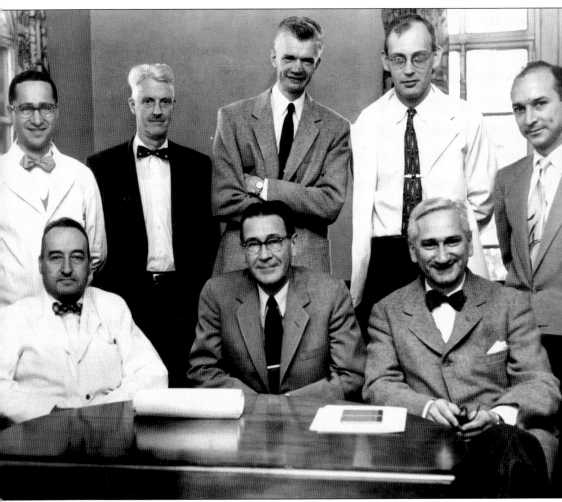

Dr. A. Ashley Weech, seated center, is surrounded by his "dream team" of directors in the 1950s. Seated are Josef Warkany (left), Division of Human Genetics, and Albert Sabin, Division of Virology. Standing from left to right are Frederic Silverman, Department of Radiology; Robert Lyon, Division of Community Pediatrics; Clark West, Division of Nephrology; Benjamin Landing, Division of Pathology; and Eugene Lahey, Division of Hematology/Oncology. Faculty not pictured are Samuel Kaplan, Division of Cardiology; Merlin Cooper, Division of Bacteriology; and George Guest, director of the Children's Hospital Research Foundation.

This photograph was taken in 1952 or 1953 to demonstrate the teamwork needed to care for the whole child. Eighty-two skills are represented. In the foreground with the patient are Jules Klein, M.D. (left), representing community pediatricians, and George DeMuth, M.D., chief resident (right).

By the 1950s, the availability of antibiotics was making new medical and surgical treatments possible for children with heart disease. With the number of patients increasing, Cincinnati Children's needed a full-time director of cardiology. Samuel Kaplan, M.D., was recruited from South Africa. He directed the Division of Cardiology for 35 years (1952–1987), becoming a revered leader in the field of pediatric cardiology.

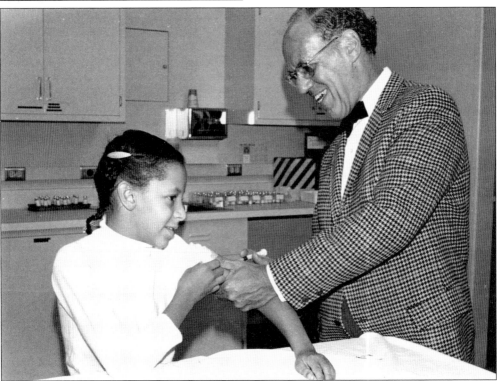

Joseph Ghory, M.D., a Cincinnati Children's physician from 1943 until his death in 1988, was the first certified pediatric allergist in Cincinnati and founder of the Division of Allergy/Immunology. He also was medical director of the Convalescent Hospital for 16 years (1961–1977). In 1984, he was honored by the American Academy of Pediatrics Allergy Section. He was the first pediatrician elected president of the Cincinnati Academy of Medicine.

Edward L. Pratt, M.D., was the chairman of the Department of Pediatrics from 1963 to 1979. During his tenure, pediatric hospital care in Cincinnati was consolidated at Cincinnati Children's, and the hospital's campus grew to accommodate new services. Affiliated pediatric services were brought on campus. Pediatric units at the General, Good Samaritan, and Jewish Hospitals were closed so that patients could be cared for in a setting where subspecialists were always available, and their pediatric residency programs moved to Cincinnati Children's. As a result of these changes, Cincinnati Children's became a comprehensive medical center. The hospital's name was officially changed from the Children's Hospital to Children's Hospital Medical Center.

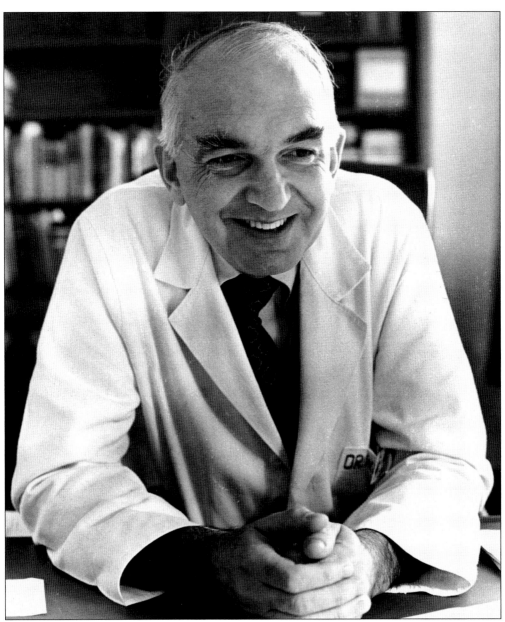

One of Dr. Pratt's first appointments was William K. Schubert, M.D. Born and educated in Cincinnati, Dr. Schubert spent seven years in private practice while maintaining a laboratory in the research foundation. In 1963, he joined the full-time faculty as the founding director of the Clinical Research Center. In 1968, he established the Division of Gastroenterology, which was just the second pediatric gastroenterology department in the country. Dr. Schubert held every major leadership position at Cincinnati Children's: chief of staff and director of the pediatric residency program (1972–1983), chairman of the Department of Pediatrics (1979–1993), and president and chief executive officer (1983–1996). He presided over years of growth in clinical and research programs and after retirement has remained active as a trustee and consultant. For his contributions to the care of children, Dr. Schubert was honored as one of the Greatest Living Cincinnatians in 2004.

The Institute for Developmental Research (IDR) opened in February 1968. Under Pres. John F. Kennedy, federal grants became available for mental retardation centers. Because of Josef Warkany's reputation, Cincinnati Children's was able to obtain a large grant to construct a building for the study of developmental defects. It doubled office and laboratory space, quadrupled animal facilities, and allowed a large influx of basic scientists. The IDR still stands, but it has been surrounded by newer buildings and is no longer visible.

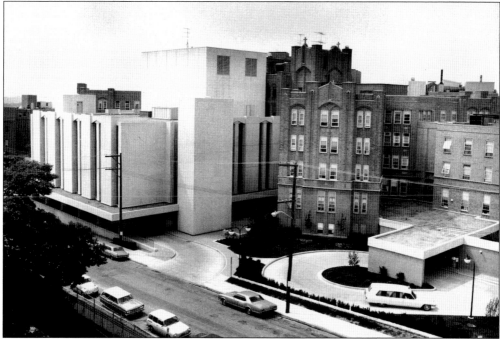

Plans were announced for a hospital expansion in 1968. Groundbreaking ceremonies were held June 16, 1968, with James Ewell, president of the board of trustees, presiding. The new south wing, at left, opened in 1971.

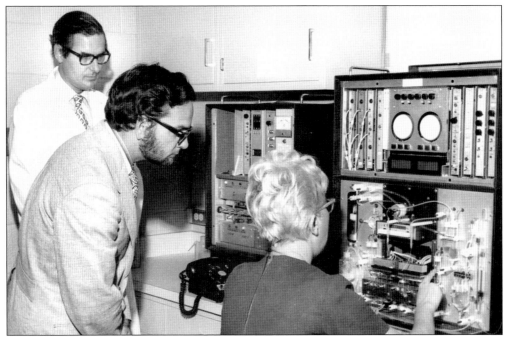

Medical technology was advancing. In this 1971 photograph taken in the new Andrew N. Jergens Memorial Hematology Laboratory, Alvin Mauer, M.D. (left), director of the Division of Hematology/Oncology (1959–1973), and Ruth Long, chief medical technician, demonstrate the new Coulter counter for Andrew N. Jergens Jr., president of the Andrew N. Jergens Foundation. The machine counted blood cells and produced almost instantaneous results compared to the previous method, hand counting under a microscope.

Cincinnati Children's purchased its first electron microscope in 1972, thanks to donations from William Schubert, M.D., his family, and friends, in memory of Dr. Schubert's father. It was now possible to study tissue changes too small to be seen under a light microscope. Here Dr. Schubert (left) is seen with John Partin, M.D., director of the Electron Microscope Laboratory, and his wife, Jacqueline Partin, a technician in the lab.

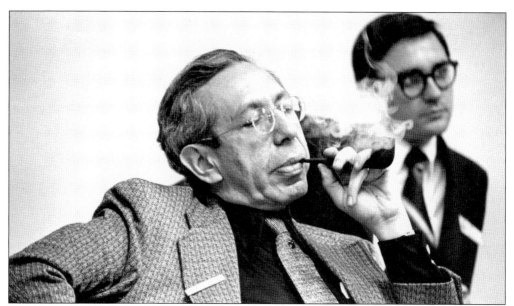

Jack Rubinstein, M.D., became the first director of the Hamilton County Diagnostic Clinic for the Mentally Retarded in 1957. The clinic later was named the Cincinnati Center for Developmental Disorders (CCDD). Dr. Rubinstein was an advocate for centralizing pediatric health care services. By 1970, several organizations had agreed to come together to form one comprehensive center at Cincinnati Children's. A new building to house the affiliated programs, including CCDD, was completed in 1973.

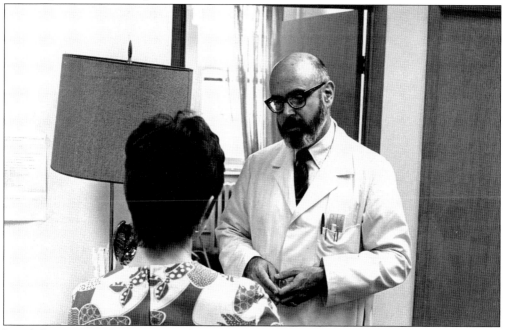

Joseph Levinson, M.D., was a consultant in arthritis at the Convalescent Hospital for Children, beginning in 1956. He established the Special Treatment Center for Juvenile Arthritis in 1962, and became the founding director of the Division of Rheumatology when services were consolidated at Cincinnati Children's in 1973.

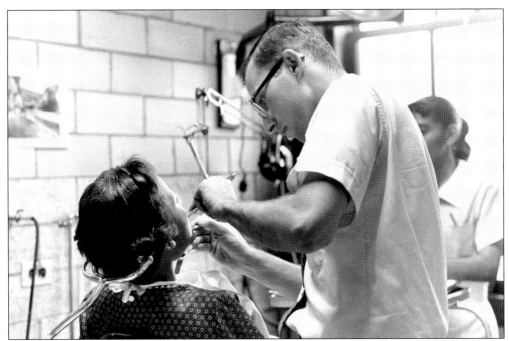

Recognizing the importance of dental care, the hospital added a dentist to the staff in 1887. Children's Dental Care Foundation was established in 1955 by Robert Lyon, M.D., and Robert Holle, D.D.S., for children who had medical conditions that complicated dental care. The foundation opened the Schell Clinic in this converted garage (below) in 1963. Pictured in front of the clinic are Clifford Steinle, D.D.S., and dental assistant Sandra Mueller. The Dental Care Foundation moved to the hospital campus in 1973.

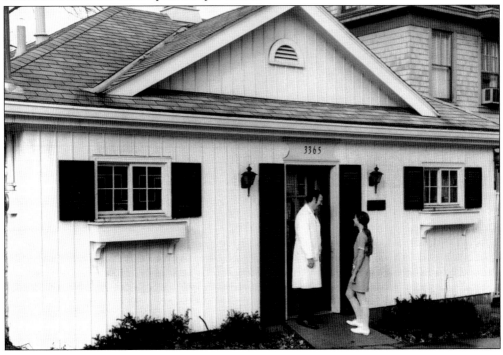

A pioneer in the field of adolescent medicine, Joseph Rauh, M.D., became director of the new Division of Adolescent Medicine in 1960 and established the Adolescent Clinic at the General Hospital. It was one of only five such clinics in the country. The clinic moved to Cincinnati Children's in 1973. A 24-bed adolescent inpatient unit opened in February 1972, greatly expanding beds for teenage patients.

Orthopedic surgeon Aaron Perlman, M.D. (center), was a consultant at the Convalescent Hospital beginning in 1951 and established a clinic for children with cerebral palsy at Cincinnati Children's. He was the hospital's first director of the Division of Orthopaedics (1965–1978). United Cerebral Palsy moved its children's program to Cincinnati Children's in 1973. This photograph was taken in the new therapeutic classroom. The program was named in honor of Dr. Perlman in 1995.

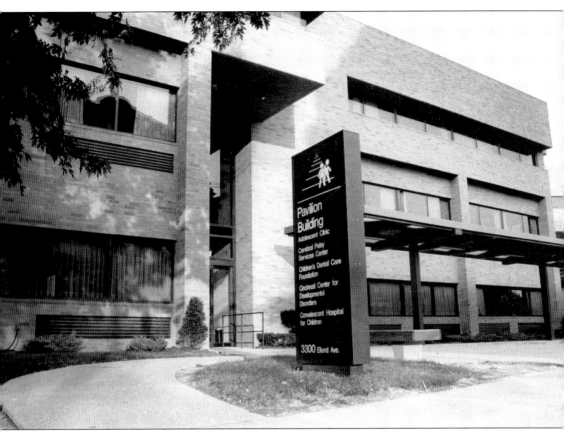

The hospital broke ground in October 1971 for a building to house the affiliated programs. Reflecting the new comprehensive organization, the hospital's name was changed from the Children's Hospital to Children's Hospital Medical Center. With construction underway in 1972, James Turner, administrative director, commented, "Children's Hospital Medical Center is no longer just an abstract idea . . . We can actually see it becoming a reality. The Pavilion is both symbol and realization of the modern approach to pediatric health care: to treat the whole child." The Pavilion Building was completed in 1973. The Convalescent Hospital for Children occupied the top floor.

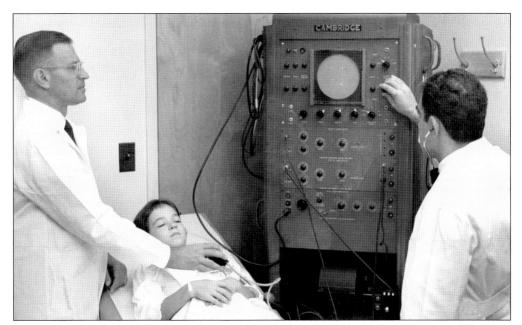

George Benzing, M.D., joined the Division of Cardiology in 1964 and was a member of the team that performed the first heart transplant at Cincinnati Children's in 1968. He also codirected the pediatric intensive care unit with Dr. Lowe. Here Dr. Benzing is using an early echocardiograph machine. He is an inventor who has developed medical devices, including a heart monitor used during open-heart surgery and a portable pacemaker monitor.

Dr. Edward Lowe (right) joined Drs. C. Nelson Melampy, director, and Theodore Striker in the Department of Anesthesia in 1971. Dr. Lowe was medical director of respiratory therapy, associate director of the Department of Anesthesia, and codirector of the pediatric intensive care unit. After a heart transplant, Dr. Lowe could no longer risk infection from patients and turned his focus to education as director of anesthesia education at the University of Cincinnati College of Medicine.

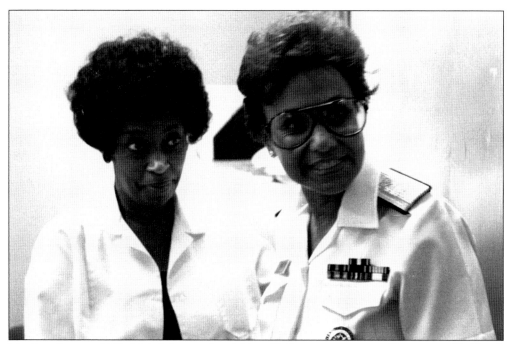

Marilyn Gaston, M.D. (right), began the sickle cell disease program at Cincinnati Children's in 1972. Later she became assistant surgeon general and rear admiral in the U.S. Public Health Service. In 1986, she published a sickle cell study that led to nationwide newborn screening. Pictured here, Dr. Gaston visited Cincinnati Children's in 1986 and reconnected with social worker Ann Huffman, who was part of the original sickle cell program team.

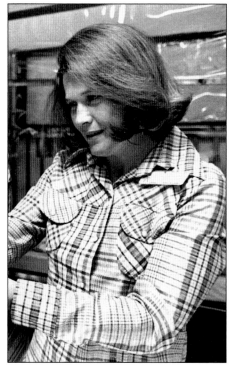

Patricia Myers, director of social work at Convalescent Hospital, became director of the Division of Social Services at Cincinnati Children's in 1977. At a time when child abuse was a taboo subject, she recognized the need for a multidisciplinary team to look after children and investigate abuse. Cincinnati Children's became one of the first to establish a child abuse team. She was an integral team member until her death in 2003.

Beatrice Lampkin, M.D., joined the Division of Hematology/Oncology in 1965 and directed the division for 18 years (1973–1991). She was the first female director of a hematology/oncology division in the United States. In the 1980s, Dr. Lampkin made important contributions to the development of new chemotherapy regimens that improved outcomes for children with leukemia.

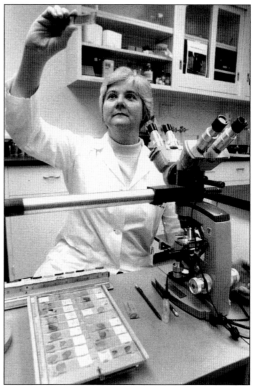

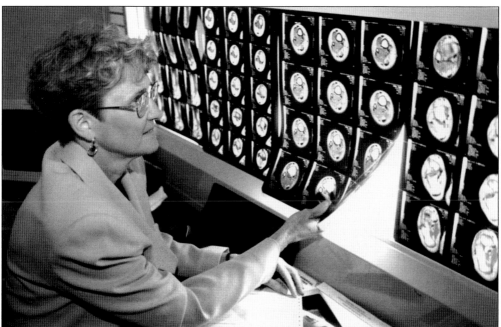

Janet Strife, M.D., trained in pediatric radiology at Cincinnati Children's and joined the faculty in 1978. As director of the Department of Radiology for 10 years (1992–2002), she helped build the department into one of the nation's leading clinical and education programs in pediatric radiology.

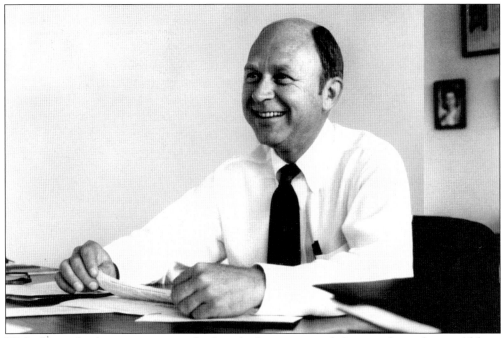

With the medical center growing, the board of trustees needed a president who would be a full-time paid trustee and chief executive officer. Lonnie Wright, M.P.H., Ph.D., was recruited in 1976 as the first president and chief executive officer. An able administrator, he helped put the medical center on solid financial footing that permitted continued expansion. He is still remembered for his sunny disposition and his uncanny ability to remember everyone's name.

The hospital employees having a good time at this holiday party in 1975 are (left to right) Cher McClanahan, R.N., then an instructor in nursing staff development, now chief executive officer of TriHealth; Pauline Heymann, R.N., director of the Department of Nursing; retired Lt. Col. Cornelia B. Callison, director of nursing staff development; and Bill Madison, director of the storeroom.

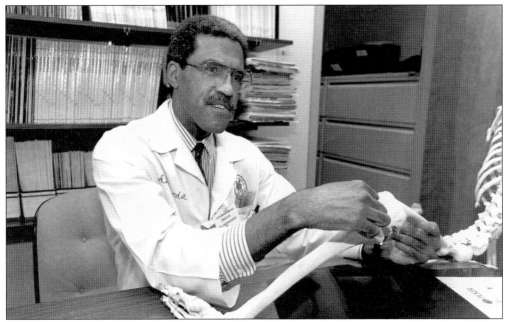

Alvin Crawford, M.D., was recruited in 1977 as the first full-time director of the Division of Orthopaedics. An internationally renowned surgeon, Dr. Crawford is one of the world's leading authorities on neurofibromatosis. He was the first in the Midwest to use thoracoscopic surgery to correct scoliosis without a large incision and is recognized as a leader in video-assisted thoracoscopic surgery.

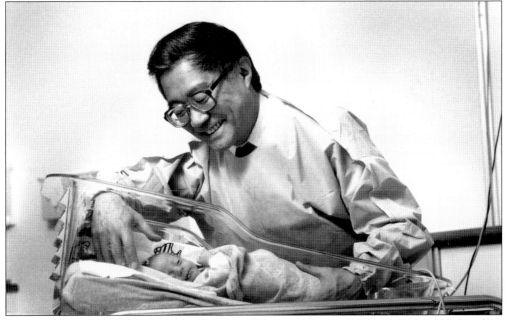

Reginald Tsang, M.B.B.S., joined the Division of Neonatology as a fellow in 1969, under founding director James Sutherland, M.D., and was appointed the second director of the division in 1983. He became a world-renowned expert on perinatal and neonatal nutrition and on diabetes in pregnancy.

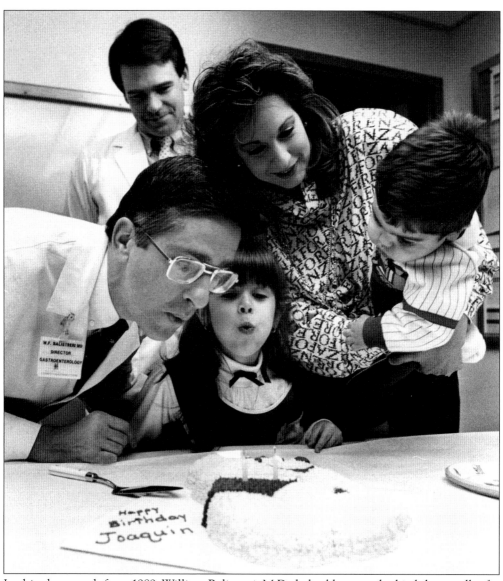

In this photograph from 1989, William Balistreri, M.D., helps blow out the birthday candles for liver transplant patient Joaquin Lopez, age two. Dr. Balistreri, who had done his residency and fellowship training at Cincinnati Children's (1970–1974), returned in 1978 as director of the Division of Gastroenterology and Nutrition. He is recognized as one of the world's foremost authorities on pediatric gastroenterology and liver disease in children. With pediatric transplant surgeon Frederick Ryckman, M.D. (standing in back), Dr. Balistreri established the Pediatric Liver Care Center in 1985 to provide outstanding diagnostic evaluation, medical, and surgical treatment, and a team approach to care. The Pediatric Liver Care Center began offering liver transplantation in 1986. Before Joaquin's first birthday, his family moved to Cincinnati from Puerto Rico so that he could be treated at the Pediatric Liver Care Center.

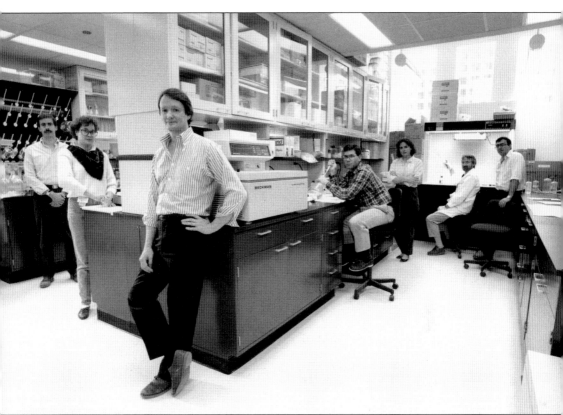

Jeffrey Whitsett, M.D. (foreground), chief of the Section of Neonatology, Perinatal, and Pulmonary Biology, is one of the world's leading experts on lung development. He first joined Cincinnati Children's in 1976 as a neonatology fellow and has been a member of the faculty since 1977. His pioneering vision to organize the system of neonatal care in birthing hospitals across Greater Cincinnati has greatly improved outcomes for newborns everywhere. Dr. Whitsett has made a series of groundbreaking contributions in pulmonary medicine, including pioneering work identifying surfactant proteins, cloning their genes, and clarifying their roles in lung development. He is a member of the Institute of Medicine and a recipient of the Mead Johnson Award for Research in Pediatrics. In this photograph from 1991, he is shown with some members of his large research team.

The Occupational Therapy and Physical Therapy programs at Cincinnati Children's merged in 1977, an innovation that enhanced the new department's ability to provide care. In this picture, occupational therapist Barbara Homlar (left) and student Colette Pacheco observe a patient climbing on equipment Pacheco made. Today the Division of Occupational Therapy and Physical Therapy is one of the largest pediatric therapy departments in the nation, and Homlar is education coordinator.

Speech pathologist Ann Kummer, Ph.D., joined Cincinnati Children's in 1976 and has directed the Division of Speech Pathology since 1981. Under her leadership, the program has grown to be one of the largest and most respected in the country. In 2006, she was honored as one of the nation's 25 most influential therapists.

Neonatologist Irwin Light, M.D., and charge nurse Vicki Howard, R.N., discuss plans for the move into the new state-of-the-art Regional Center for Newborn Intensive Care, which opened in 1978. Dr. Light began his career at Cincinnati Children's in 1963 as a research fellow in neonatology. He directed the newborn clinical service from 1973 to 1983.

In the 1960s, neonatologist Paul Perlstein, M.D., led a team of physicians and engineers, including Dr. James Sutherland, Neil Edwards, and Harry Atherton, from Cincinnati Children's and the University of Cincinnati in developing Alcyon, a computerized system that continuously monitored vital functions and controlled the incubator environment of newborns in the intensive care unit. By the 1970s, with these computerized incubators, Cincinnati Children's and General Hospital had the most technologically sophisticated newborn intensive care units in the world.

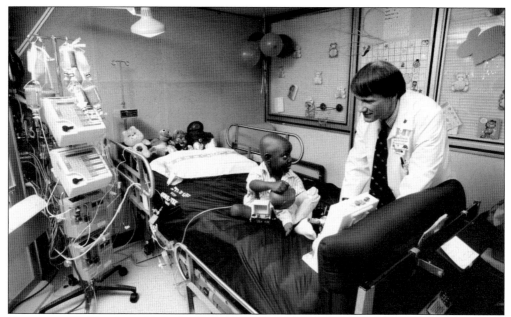

Cincinnati Children's established a bone marrow transplant unit in 1981, directed by Richard Harris, M.D. In this photograph from 1988, Dr. Harris checks on three-year-old Marlow Robinson. Today the bone marrow transplant program, directed by Stella Davies, M.B.B.S., Ph.D., is one of the largest in the country and is recognized for expertise in treating unusual disorders. In 2005, the program achieved a milestone, performing its 1,000th transplant.

Mark Sperling, M.D., an internationally known pediatric endocrinologist and diabetes expert, joined Cincinnati Children's in 1978. While there had been services for children with diabetes earlier, Dr. Sperling founded the Division of Endocrinology, built the staff, and expanded research. He also established a fellowship program that has produced many distinguished graduates. Dr. Sperling was appointed chairman of the Department of Pediatrics at Children's Hospital of Pittsburgh in 1989.

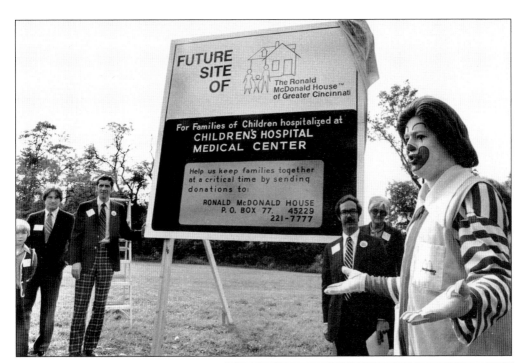

Plans for a Ronald McDonald House, where out-of-town families could stay while their children were hospitalized, were announced in September 1980, at a press conference on the site of the future house. The Children's Family House obtained a 99-year lease from Cincinnati Children's for $1. Pictured at the lease signing ceremony are (left to right) Lonnie Wright, Ph.D., president and chief executive officer of Cincinnati Children's; Louis Groen, owner of the Ronald McDonald franchise; and nephrologist Paul McEnery, M.D., who continues to serve on the Ronald McDonald House board of trustees. The house opened in 1982. A new, larger house with 48 bedrooms opened in 2001, and work to add another 30 rooms began in 2008.

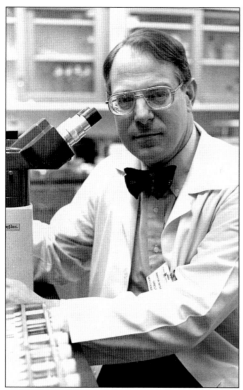

Martin Myers, M.D., created and directed the Division of Infectious Diseases (1981–1993) and led the infection control program. Previously, adult infectious disease experts had consulted with hospital physicians. Dr. Myers and the team he built brought new expertise in diagnosing and managing serious infections in children. The research program he established, focused on herpes virus infections, continues today. He left in 1993 to be chairman of the Department of Pediatrics at Northwestern University.

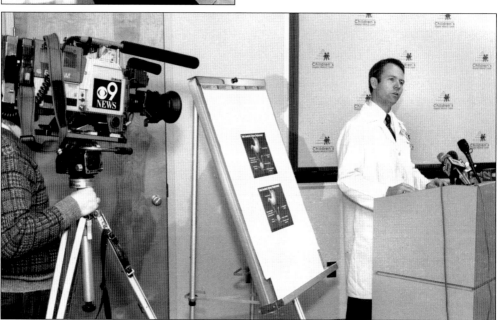

Curtis Sheldon, M.D., was appointed director of the new Division of Pediatric Urology in 1987. In this photograph taken at a news conference in 1992, he reports on a successful urinary tract replacement performed on an 18-year-old girl with very complex urinary system problems. While the components of the procedure had been done individually, no one had put them together before to totally replace a patient's urinary system.

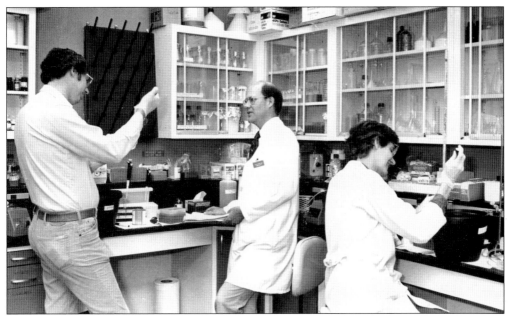

With scientists using revolutionary new techniques to study genes at the molecular level, Cincinnati Children's recruited John Hutton, M.D. (center), as vice chairman of the Basic Science Research program in 1984 to enhance molecular genetics research. He was appointed dean of the University of Cincinnati College of Medicine in 1987. When he stepped down in 2002, Dr. Hutton returned to research at Cincinnati Children's and is now vice president and director of the Division of Biomedical Informatics.

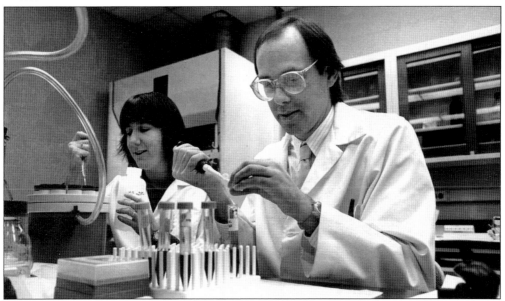

Among Dr. Hutton's first recruits, in 1985, were Sandra Degen, Ph.D., and Jay Degen, Ph.D. Today Jay's research focuses on genetic analysis of hemostatic (coagulation) factors in common disease processes, including cardiovascular disease and cancer. Sandra has been a strong advocate for women in science. She is now vice president for research at the University of Cincinnati and associate director for academic affairs at Cincinnati Children's.

By the hospital's centennial year, 1983, the delivery of health care services was changing. More and more care was being provided in an outpatient setting, and Cincinnati Children's responded by constructing the Ambulatory Services Building (now Location C) to house outpatient clinics. The building had three floors when it opened in 1983. Two floors were added later.

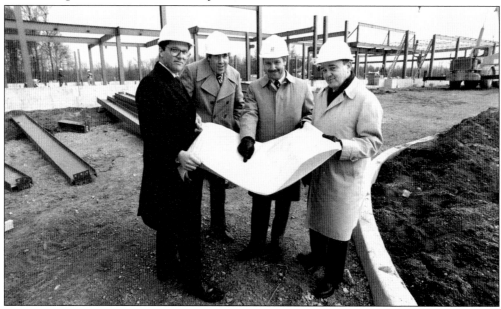

In 1985, Cincinnati Children's announced plans to build an outpatient center in Mason for clinic visits and outpatient surgery. It would be the nation's first satellite center offering pediatric surgery outside the hospital setting. This photograph shows hospital leaders visiting the construction site in January 1987. At right is pediatric anesthesiologist Theodore Striker, M.D., then director of the Department of Anesthesia, who has been medical director of the center since it opened.

Children's Outpatient North (now Mason Campus) opened in June 1987. Services included outpatient clinics, diagnostic tests, therapy, and outpatient surgery. There were 2,000 surgical patients in the first year. Not one had to be admitted to the hospital. A hospital leader commented, "We were confident we could provide outstanding quality and safety in a remote location, but since it had never been done before, we had to demonstrate it." Children's hospitals across the country were watching to see if it would be successful.

Char Mason, R.N., holds an armful of medical charts after a busy morning of surgical procedures at Children's Outpatient North. The nursing staff worked in a unique way. Nurses were organized into a self-directed work group and rotated through each of the nursing roles. Today Mason is vice president for Outpatient and Home Care Services.

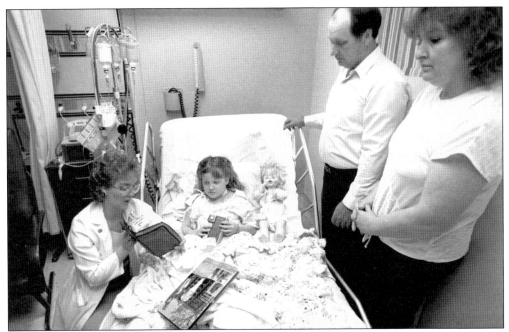

The Division of Home Health Care was launched in April 1988 to improve the continuity of care for the growing number of children who were discharged from the hospital but required continuing complex treatment at home. Here, Paula Cuthrell, R.N., teaches a patient and her parents how to administer central line intravenous medications at home.

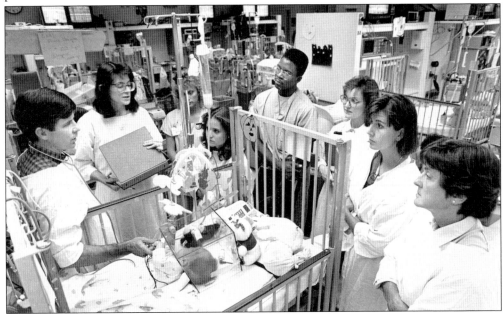

In this scene of bedside teaching in 1988, residents make rounds in the Regional Center for Newborn Intensive Care, led by neonatologists Edward Donovan, M.D. (left), and Jeanne Ballard, M.D. (right). As this photograph demonstrates, by the 1980s more women were choosing careers in medicine, and particularly pediatrics. The male resident pictured here, Bradley Jackson, M.D., is now a community pediatrician and former president of the Medical Staff (2000–2001).

Carolyn Stoll, R.N. (right), took nursing practice at Cincinnati Children's to a new level of achievement by strengthening the role of the bedside nurse and introducing a structured system for clinical advancement. Here in a photograph from 1987, colleagues from the Departments of Nursing and Human Resources surprise her with a thank you for her leadership during a challenging year.

David Glass, M.D. (center), was recruited as the second director of the Division of Rheumatology in 1987. He established a basic research program that has become the nation's leading center for the study of the role of genes in causing juvenile arthritis and other rheumatic diseases in children. Today Dr. Glass is associate director of the Cincinnati Children's Research Foundation.

Dorine Seaquist, R.N. (right), newly appointed vice president for Nursing, is greeted at a welcome reception in October 1989. During her tenure, Seaquist was an advocate for family-centered care and for a team approach to care. She integrated all nonmedical clinical services into one comprehensive Department of Patient Services, including the Divisions of Nursing, Pharmacy, Social Services, Clinical Nutrition, Speech Pathology, Occupational Therapy/Physical Therapy, Respiratory Care, Child Life/Recreation Therapy, Audiology, and Volunteer Services.

In 1984, Cincinnati Children's had 121 research professionals. By 1991, there were 170. New facilities were needed to provide room for expanding programs and help the medical center attract and retain the brightest investigators. In 1987, the board of trustees approved plans for a new research building, the first since 1968. It opened in 1991, adding 120,000 square feet and housing 19 programs in 240 new laboratories.

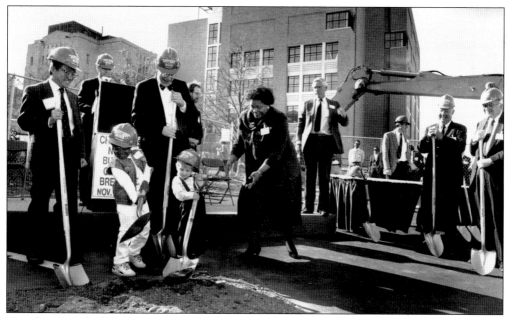

New hospital facilities also were needed to keep up with the pace of medical advances and growth in clinical services. On November 16, 1990, Cincinnati Children's broke ground for a new hospital building, with two patients, Marlow Robinson (left) and Danny Osbourne, taking center stage.

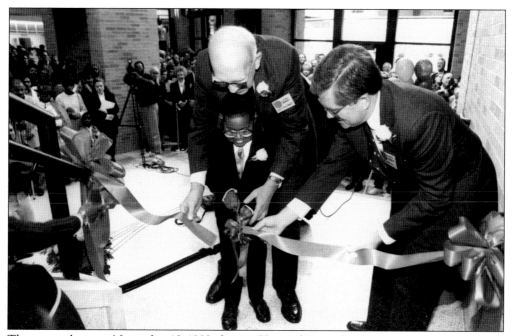

Three years later, on November 13, 1993, the new Hospital Tower (now Location B) was dedicated. Marlow Robinson, now 9, returned to cut the ribbon. Helping him are William Schubert, M.D. (left), president and chief executive officer, and James Anderson, chairman of the board of trustees. Anderson succeeded Dr. Schubert as president and chief executive officer in 1996.

Staff made it fun when the first patients moved into the Hospital Tower on December 5, 1993. The date was almost exactly 67 years after patients had moved into the Procter/Mitchell hospital on December 6, 1926. The Hospital Tower provided 18 new operating rooms; state-of-the-art facilities for emergency, radiology, and intensive care services; a rooftop helipad; and improved amenities for families.

Michael Farrell, M.D., chief of staff since 1993, came to Cincinnati Children's in 1974 for his pediatric residency. After fellowship training, he joined the Division of Gastroenterology and Nutrition in 1979. An educator and innovator, he directed the pediatric residency program (1982–2001) and established the nutrition support team, feeding team, and short bowel clinic. He has been medical director of Home Health Care since its inception in 1988.

Dr. Farrell
Chief Of Staff

Jeffrey Robbins, Ph.D., director of the Division of Molecular Cardiovascular Biology, joined Cincinnati Children's in 1993 to pursue studies of the causes and treatment of pediatric heart disease. He developed materials that have allowed hundreds of scientists to create accurate models of pediatric heart disease so that the exact causes can be defined and new therapeutic avenues discovered. Dr. Robbins won the 2005 American Heart Association Scientific Achievement Award for his landmark research. In 2008, he was named executive director of the new Heart Institute at Cincinnati Children's.

In 1993, Thomas Boat, M.D., became the chairman of the Department of Pediatrics, physician-in-chief, and director of the Children's Hospital Research Foundation. During his 14-year tenure, the clinical and research faculty more than doubled, and research grant funding grew from under $20 million to over $120 million. In a 2007 *U.S. News & World Report* survey of medical school deans and senior faculty, the Department of Pediatrics was ranked in the top three pediatric programs at a medical school. Dr. Boat also became a leading voice nationally for transformational change, challenging his peers in academic medicine to improve the quality and safety of care in the United States. Since stepping down as chairman in 2007, Dr. Boat has accepted a new role as executive associate dean for Clinical Affairs at the University of Cincinnati College of Medicine.

Four

CLINICAL AND RESEARCH ACHIEVEMENTS

In 1996, Cincinnati Children's declared: "Our vision is to be the leader in improving child health."

Although the goal may not have been stated with such simplicity and boldness before, it is clear that as early as the Procter-Mitchell years, Cincinnati Children's aspired to leadership in pediatrics. In fact, as Dr. Albert Graeme Mitchell was preparing to move here in 1924, he wrote, "I want to make Cincinnati one of those places . . . from which the solution of constructive and helpful Pediatric work will proceed."

Cincinnati Children's has often been on the leading edge—in the forefront of open-heart surgery, organ transplant, and other complex procedures; an innovator in developing new diagnostic tools and medications; and a leader in advancing knowledge of human biology and genetics, health, and disease.

Among the first important contributions to come from the Children's Hospital Research Foundation was the work of Josef Warkany, M.D. His research on deprivation of vitamins D and A showed that birth defects could be caused by nutritional deficiency or other environmental factors. Dr. Warkany became known as the "father of teratology," the study of birth defects. His monumental single-author book, *Congenital Malformations*, is still used throughout the world.

Of the many notable accomplishments at Cincinnati Children's, none has had a wider impact than the work of Albert Sabin, M.D., who joined the Children's Hospital Research Foundation in 1939. Dr. Sabin gave the world an extraordinary gift—the oral polio vaccine that conquered polio around the globe. As one physician and scientist at Cincinnati Children's put it, Dr. Sabin's vaccine alone justified "every penny of William Cooper Procter's great gift" that launched the research foundation.

Today after more than a decade of intensive investment in building leading-edge medical, surgical, and research programs, Cincinnati Children's is contributing to the advancement of pediatric medicine in more ways than ever before. The goal is to extend the boundaries of knowledge through innovative laboratory and clinical research, and—most importantly—to apply that knowledge to change the outcome for children in Cincinnati, across the United States, and around the world.

This chapter highlights some of the many physicians and scientists whose contributions profoundly improved the lives of children and their families.

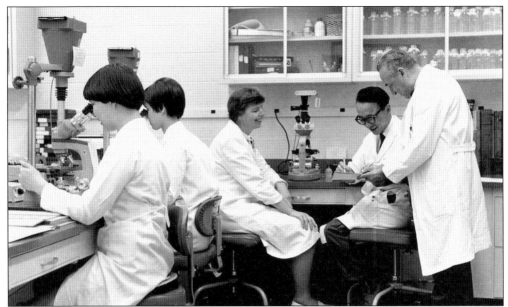

Josef Warkany, M.D. (standing), came from Vienna in 1932 for a one-year fellowship and spent his entire career at Cincinnati Children's. His early research showed that mercury in teething powders and ointments caused acrodyna, a painful childhood disease. In other experimental work, he showed that vitamin D and A deprivation in the mother rat caused birth defects in the offspring. From these observations, Dr. Warkany began his lifelong study of teratology and became known as the "father of teratology." In 1960, he cofounded and served as first president of the Teratology Society. In 1970, he received the John Howland Award, the highest honor of the American Pediatric Society. In 1971, he completed his 1,300-page textbook, *Congenital Malformations*. In 1985 (below), he received the Daniel Drake Medal from the University of Cincinnati College of Medicine.

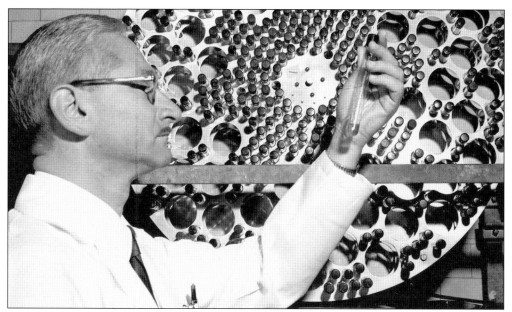

Albert Sabin, M.D., spent 30 years at Cincinnati Children's (1939–1969). During World War II, he did research for the Department of War on encephalitis, sandfly fever, and dengue fever. After the war, he returned to his long-standing interest: polio. He observed that children in urban areas with poor sanitation had protective antibodies in their blood, suggesting they had been infected by a weakened strain that had produced immunity. Based on this observation, he developed his live-virus oral vaccine.

In 1957, the World Health Organization chose the Sabin vaccine for worldwide testing. Millions of doses were given in Russia, Holland, Mexico, Chile, Sweden, and Japan. The first clinical test in the United States was in Cincinnati. On Sabin Sunday, April 24, 1960, thousands of families came to Cincinnati Children's for free Sabin vaccine.

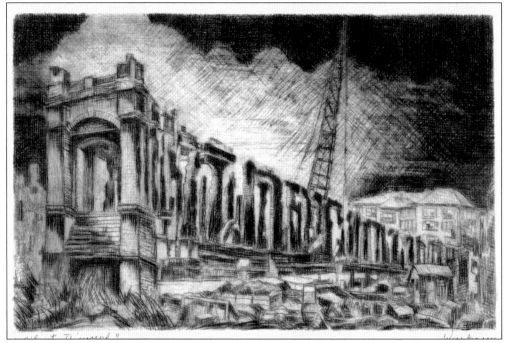

This etching by Josef Warkany, M.D., an accomplished artist as well as scientist, is titled *Silent Triumph: Demolition of Cincinnati Contagious Hospital, 1973*. In the wake of the polio vaccine and other advances in fighting infectious diseases, the old Contagious Hospital was no longer needed.

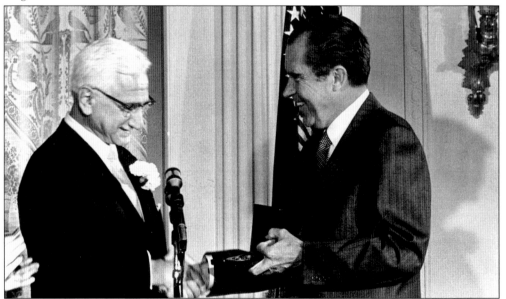

Dr. Albert Sabin received many honors. In this photograph from May 1971, he receives the Presidential Medal of Freedom from Pres. Richard Nixon. Locally he was among the first group to receive the Daniel Drake Award, the highest honor of the University of Cincinnati College of Medicine. On July 4, 1986, he received the Liberty Medal during the 100th anniversary of the Statue of Liberty.

Helen Berry, M.S., did pioneering research on phenylketonuria (PKU), a genetic inability to metabolize an amino acid in protein, resulting in severe mental retardation. Berry helped develop a test to detect PKU and was a proponent of early screening. She spent years developing a dietary supplement that made it possible for PKU patients to eat a less restrictive diet, the first major improvement in treatment of PKU in 30 years.

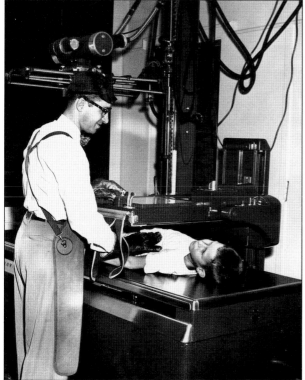

Frederic Silverman, M.D., was the hospital's first full-time director of the Department of Radiology (1947–1975). An outstanding physician and teacher, he is considered a founding father of pediatric radiology. A pioneer in the use of diagnostic radiology to identify child abuse, he urged physicians to come to grips with a problem they had avoided. In 1988, Dr. Silverman was the first recipient of the Gold Medal of the Society for Pediatric Radiology.

In the 1950s, pediatric cardiologist Samuel Kaplan, M.D. (above), teamed up with surgeon James Helmsworth, M.D. (seen at left in a photograph from 1982), radiologist Frederic Silverman, M.D. (previous page), and inventor Leland Clark, Ph.D. (next page), to develop new techniques for diagnosis and treatment of heart disease. Cincinnati Children's became a leader in open-heart surgery, and the cardiac service was so busy that heart patients occupied more than half the beds in the hospital.

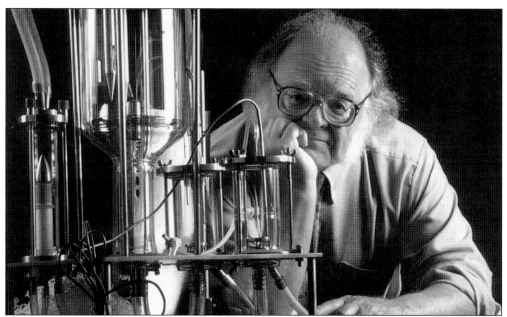

Chemist Leland Clark, Ph.D. (above), director of the Division of Neurophysiology, was a brilliant scientist and prolific inventor. Among his inventions is the Clark oxygen electrode, which is used worldwide to measure the oxygen level in blood. He did important research on the use of fluorocarbon liquids as a substitute for blood. While he was a member of the Department of Biochemistry at Antioch College, he invented the bubble-defoam oxygenator heart-lung machine (below) and brought his invention to the cardiology team at Cincinnati Children's. Using this machine for extracorporeal oxygenation, the team performed the first open-heart surgery in 1952.

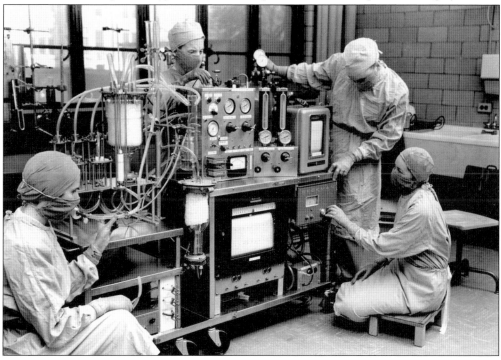

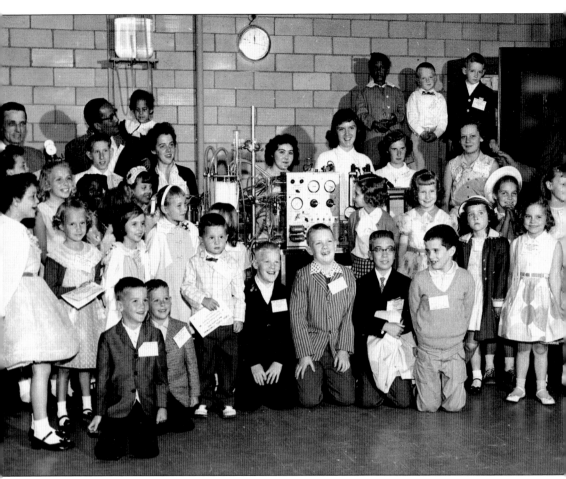

This picture from 1959 was taken at a reunion of the children who had had open-heart surgery at Cincinnati Children's. They are gathered around the heart-lung machine that took unoxygenated blood from the heart, oxygenated it, and returned fully oxygenated blood to the body—making open-heart surgery possible.

David Schwartz, M.D., joined the cardiology faculty in 1967, after a fellowship under Dr. Samuel Kaplan. Dr. Schwartz directed the cardiac catheterization laboratory and developed equipment and techniques that are still in use. Here he is holding a soft, maneuverable catheter he invented, known as the flow directed infant angiographic catheter, that improved the safety of angiography procedures. In 1988, Dr. Schwartz became the second director of the Division of Cardiology.

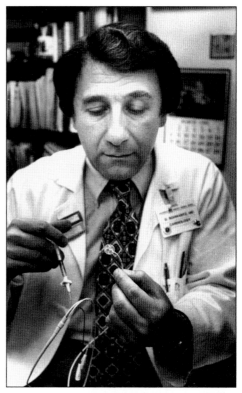

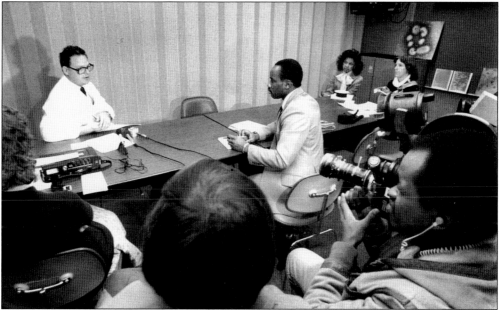

John Partin, M.D., pictured at a news conference in 1980, and William Schubert, M.D., did important research on Reye syndrome, which causes liver disease and life-threatening brain injury. They used a special needle to biopsy the liver and secure liver tissue without subjecting patients to major surgery, used the electron microscope to identify the mitochondrial abnormality, and participated in a statewide study that showed a link between Reye syndrome and aspirin.

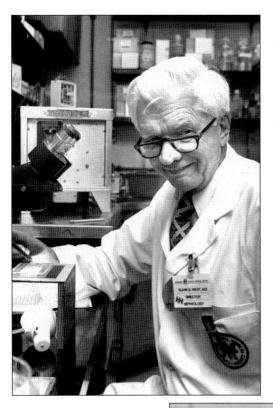

Clark West, M.D., pictured here in 1981, joined Cincinnati Children's in 1950. He founded the Division of Nephrology and was part of the team that performed Ohio's first kidney transplant in 1965. Dr. West made major contributions to the understanding of kidney disease in children. He retired in 1989 but continued to do productive research until 2008, at age 89. He received the American Society of Pediatric Nephrology's Founders Award in 2008.

Lester Martin, M.D. (facing camera), the first pediatric surgeon in Cincinnati, directed the Division of Pediatric Surgery from 1957 to 1989. He performed the first kidney transplant in Ohio, in 1965, and the first liver transplant at Cincinnati Children's. His innovation and skill as a surgeon resulted in greatly improved outcomes for complicated gastrointestinal surgery, including surgery for Hirschprung disease and ulcerative colitis.

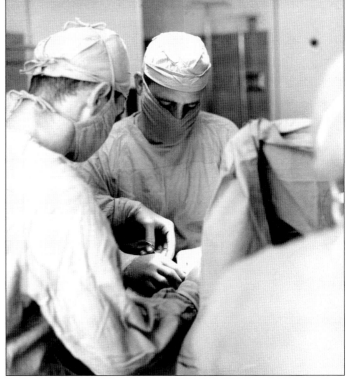

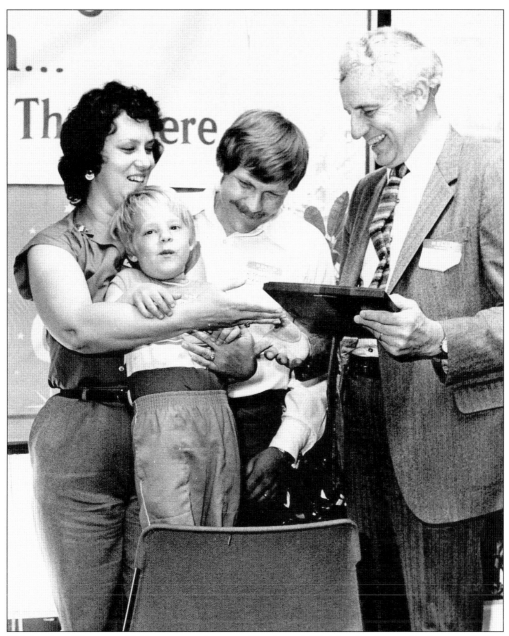

Celebrating 20 years of kidney transplants at Cincinnati Children's, the medical center held a reunion for 150 transplant patients and their parents in 1985. Here a patient and his parents present surgeon Lester Martin, M.D., with a plaque.

At a news conference in January 1988, neonatologist Jeffrey Whitsett, M.D., announced a major breakthrough. The research team he led had identified and cloned two proteins essential to the production of human surfactant, a substance that keeps lungs pliable so they can easily expand and contract as one breathes. Dr. Whitsett's discovery revolutionized care for premature newborns around the world. It now was possible to use recombinant DNA technology to produce large quantities of human surfactant to treat respiratory distress syndrome, a life-threatening disease of premature infants whose lungs are too immature to produce surfactant. Today surfactant replacement therapy saves thousands of lives every year. Dr. Whitsett is now chief of the Section of Neonatology, Perinatal, and Pulmonary Biology.

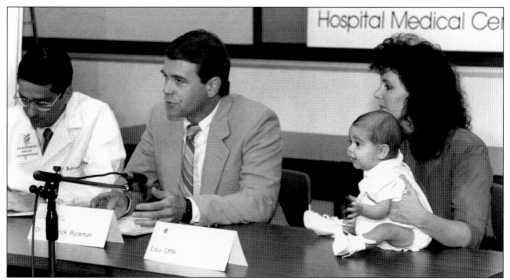

At a news conference on August 23, 1988, gastroenterologist William Balistreri, M.D. (left), and surgeon Frederick Ryckman, M.D., reported that the Pediatric Liver Care Center team had performed its first segmental liver transplant on July 2. Unperturbed by the roomful of reporters, bright lights, and microphones, the patient, nine-month-old Michelle Offik, smiled and gurgled in her mother's arms. Segmental transplant is widely used today, but at the time, only one other medical center in the United States had attempted it. The procedure allows surgeons to divide a larger liver and use a segment for a transplant. Because organs for donation are scarce, particularly for infants, segmental transplant increases the pool of possible donor organs. Eight years later, Michelle, pictured below with her younger sister, was doing well. Today she is a college student.

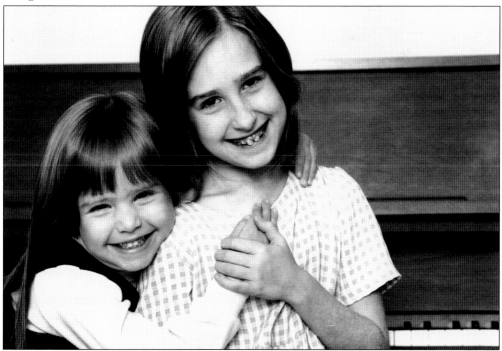

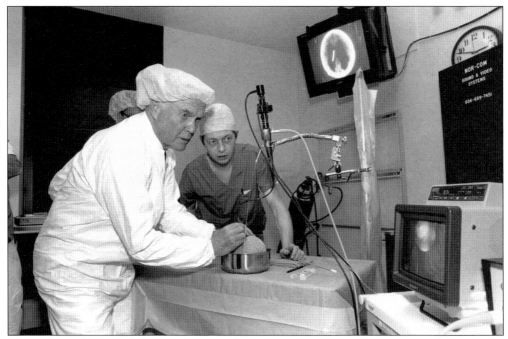

Kerry Crone, M.D. (right), now director of the Division of Neurosurgery, joined Cincinnati Children's in 1986 and quickly received recognition for rare brain surgery using laser technology. In 1991, he gave U.S. Sen. John Glenn a chance to try his hand at laser neurosurgery, using a cantaloupe as a patient. Today Dr. Crone has access to the world's most advanced technology in the hospital's new brain suite, which opened in 2007.

One of Dr. Crone's first patients at Cincinnati Children's was five-and-a-half-month-old Brent Hammergren, who suffered disabling seizures every day from a rare and severe brain condition. In landmark surgery that received worldwide attention, Dr. Crone removed the malformed lobes of Brent's right brain. Today Brent is 21 and a student in Cincinnati Children's Project SEARCH program, a training and employment program for young adults with disabilities.

In 1987, Kenneth Setchell, Ph.D. (above, at center, facing forward), seen here at an open house in the Mass Spectrometry Laboratory, and William Balistreri, M.D. (below), director of the Division of Gastroenterology and Nutrition, did breakthrough research on bile acid metabolism that revolutionized evaluation and treatment of children with liver disease. Using new mass spectrometry techniques, Dr. Setchell analyzed blood and urine samples from three-week-old twins who were critically ill with an undiagnosed liver disease. He found an error in metabolism that prevented normal production of bile acids by the liver. Dr. Balistreri then pioneered a new therapy to bypass the metabolic block by feeding bile acids and restoring liver function. These techniques have been applied to a variety of liver disorders since then.

Seth and Josh Gregory were diagnosed with a previously unknown inborn error of bile acid metabolism in 1987 and were treated by being fed bile acids. After seven months of treatment, the boys were gaining weight, and biopsies showed their liver disease was stabilized. By the time this photograph was taken in 1989, Seth and Josh had been weaned from bile acid treatment.

Internationally renowned surgeon Robin Cotton, M.D., director of the Division of Pediatric Otolaryngology/ Head and Neck Surgery since 1973, has built the world's premier center for diagnosis and treatment of airway abnormalities. He was instrumental in creating the Aerodigestive and Sleep Center, a unique interdisciplinary center that treats children with complex airway, pulmonary, sleep, feeding, and digestive disorders. Dr. Cotton developed a tracheal reconstruction procedure that saves children from a lifetime of dependence on a tracheotomy tube to help them breathe. Patients travel to Cincinnati Children's from around the nation and the world for this procedure. Below, Dr. Cotton examines Bernardo Tamez, who came from Mexico for tracheal reconstruction in 1989.

Pediatric rheumatologist Daniel Lovell, M.D., M.P.H., organized and was a principal investigator of a national clinical trial of etanercept, a new biologic treatment for severe juvenile idiopathic arthritis. The successful trial revolutionized treatment of children with arthritis that is resistant to other medications. Here Dr. Lovell is pictured with study participant Trisha Seletyn. Within two weeks of starting the trial, she had no evidence of joint inflammation and was symptom free.

Nephrologist John Bissler, M.D., is the lead inventor of a hemofiltration machine that dramatically improved the accuracy and safety of hemofiltration and dialysis treatments and made possible continuous hemofiltration and dialysis in critically ill patients. The "intelligent," computer-controlled system uses specially developed software that makes automatic adjustments as needed. Dr. Bissler's technology is now used in hemofiltration and dialysis equipment around the world, helping children and adults with kidney failure.

Marc Rothenberg, M.D., Ph.D., director of the Division of Allergy/Immunology, is internationally recognized for pioneering research on the molecular mechanisms of allergic inflammation, particularly eosinophilic disorders. He established the Cincinnati Center for Eosinophilic Disorders in 2005. The center is leading the world by bringing together experts in allergy/immunology, gastroenterology, and pathology to evaluate, treat, and study these chronic disorders. Dr. Rothenberg received the Mead Johnson Award for Research in Pediatrics in 2007.

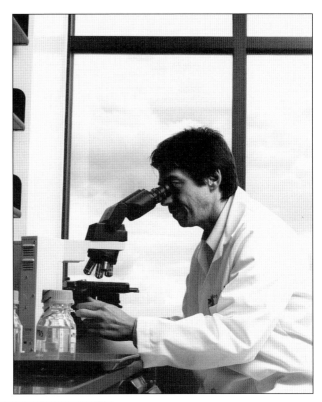

Neurologist Tracy Glauser, M.D., recognized that information about a patient's genetic makeup would help doctors prescribe the safest, most effective medication and dose. He and colleagues at Cincinnati Children's launched the Genetic Pharmacology Service (GPS), the first such service at a pediatric hospital. The GPS laboratory's analysis of a blood sample might show that the patient will not respond to a drug, or will need a larger or smaller dose.

In the tradition of Dr. Albert Sabin, Cincinnati Children's continues to be a leader in vaccine research, and is one of just eight federally designated Vaccine and Treatment Evaluation Units. The research team of Richard Ward, Ph.D. (above), and David Bernstein, M.D. (left), developed and conducted early clinical trials of a successful rotavirus vaccine. First licensed in Mexico in 2004, it is now used in 100 countries and received FDA approval in the United States in 2008. Commercial use of this vaccine is the culmination of 20 years of research that took it from the laboratory to clinical trials in the United States, Europe, Latin America, Africa, and Asia. Dr. Bernstein thanks the parents whose children participated in the earliest tests. "Someone had to be the first child to take it," he says. "The involvement of hundreds of kids in Cincinnati may prevent 500,000 deaths a year in kids around the world."

Five

PLAY, THE VITAL WORK OF CHILDHOOD

Because play is essential in the life of the child, Cincinnati Children's incorporates opportunities for play into each day. Play offers children a chance to have fun, learn, and develop. It links them to home and family, to everyday routines, to the familiar.

When the hospital organized recreation services with a paid staff in 1931, it became just the second children's hospital to do so. There had been voluntary efforts for recreation as early as 1890.

In 1931, the Division of Child Life had four staff members. Today Child Life has a staff of over 100. Programs are provided for patients from birth through young adults—in the activity centers, the infant/toddler room, the teen room, an outside play deck, and at the bedside, and also in the Emergency Department, Radiology Department, Same Day Surgery, and many outpatient areas.

Play may take many forms, depending on the current needs of the child. Tiny babies are tenderly held and gently rocked. Caregivers softly talk and sing to infants, helping them feel comfort and security. Toddlers are given a chance to be independent, to test their new skills of crawling or walking in a safe space. They can choose from appropriate toys to explore. Preschool and school-age children engage in favorite and familiar activities, including songs, games, and crafts. Teens enjoy interacting with peers in a room designed especially for them. Children of all ages can touch the smooth fur of visiting dogs and delight in a visit from a celebrity they recognize.

The hospital school program, in existence for over 50 years, offers familiar, normal activity during the child's hospitalization, building self-esteem, and preparing the child for the transition back to the regular classroom. Therapeutic play contributes to high quality medical care. Child Life specialists prepare and support children and their families through health care experiences. They use developmentally appropriate teaching materials to reduce the child's fears and misunderstandings. As the child's anxiety and pain decrease, the healing process is enhanced.

The photographs collected in this chapter offer images of children learning and playing, doing the vital work of childhood.

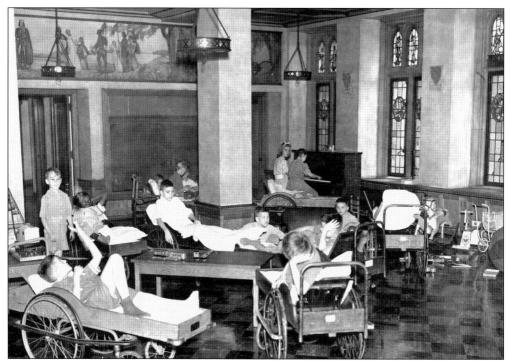

Children who were on medical orders not to walk were transported to the playroom on carts so they could enjoy activities with other children.

Special occasions are not forgotten, even though the child is in the hospital. Here two children celebrate their birthday.

Children's pets are part of their everyday lives. Pet visits are scheduled so that children can continue to have contact with these special friends.

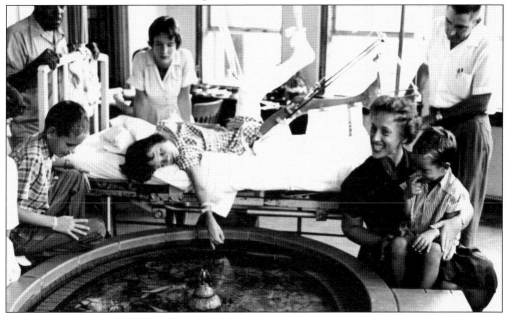

In this scene from 1961, a family visit takes place at the Rookwood fishpond in a solarium outside the playroom. Holding a child on her lap is Patricia O'Reilly, Ph.D., director of the Division of Recreation (now Child Life) for 14 years. Dr. O'Reilly later joined the faculty of the University of Cincinnati College of Education and received the 2003 Distinguished Alumni Award for contributions to the university and the community.

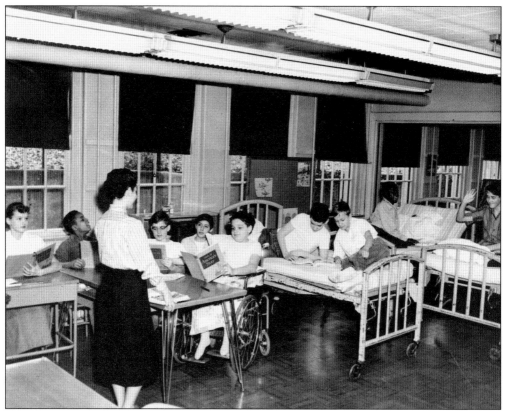

When at home, the child goes to school. This important part of the child's life is continued in the hospital. Cincinnati Children's has had a school program for over 50 years.

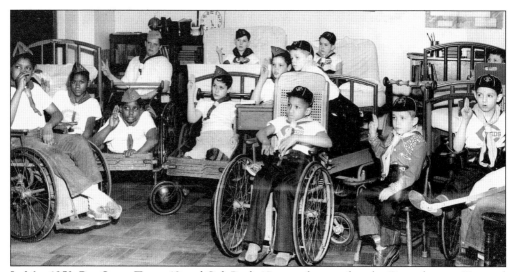

In May 1953, Boy Scout Troop 48 and Cub Pack 48 were chartered at the Convalescent Hospital for Children.

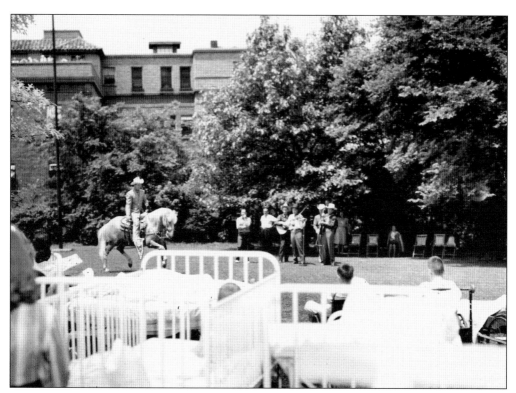

Throughout its history, Cincinnati Children's has had many visits by celebrities. In 1949, Roy Rogers and Trigger visited, accompanied by Bob Nolan and the Sons of the Pioneers. They are outside in the play yard, where the children played daily, weather permitting. Having been born and raised in this area, Roy Rogers had a lifelong connection to Cincinnati. He visited children in the hospital again in July 1988.

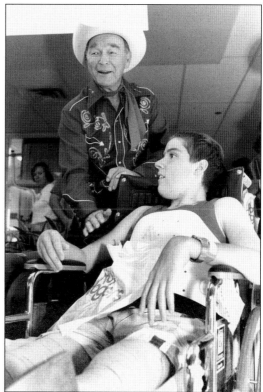

In 1973, heart patients at Cincinnati Children's enjoyed a day at Riverfront Stadium for the second annual Reds Rally. The event raised money for the cardiology program. Here Samuel Kaplan, M.D. (left), director of the Division of Cardiology, and cardiologist David Schwartz, M.D. (right), join two patients on the field, with Reds team manager Sparky Anderson.

Cincinnati Bengals' player Icky Woods danced in the end zone whenever he scored a touchdown. The "Icky shuffle" was the talk of Cincinnati in the 1988–1989 football season. In January 1989, he came to Cincinnati Children's to teach patients how to do the dance.

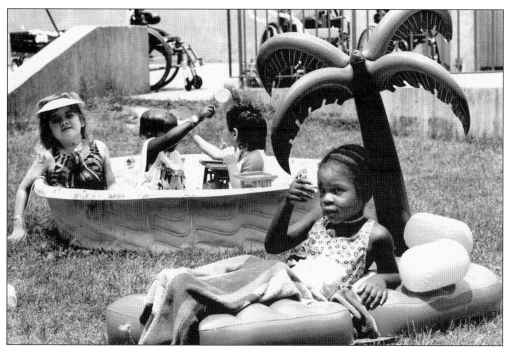

In Cincinnati's hot summers, it is nice to be able to relax at the pool. The hospital had a kiddy wading pool in the play yard in the 1950s and on the play deck in the 1970s. The children pictured here are having a great time at a pool party in August 1990.

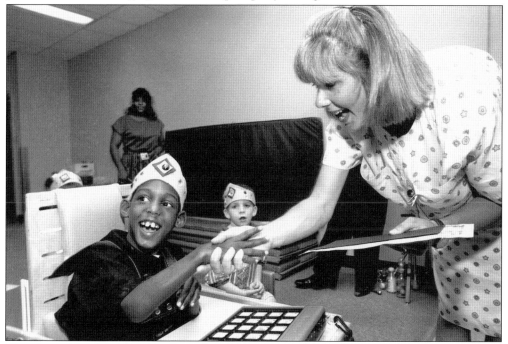

The therapeutic preschool program at the Aaron W. Perlman Center for Children prepares children with cerebral palsy and other chronic physical disabilities for mainstreaming into kindergarten. Here in 1995, a five year old receives his graduation certificate.

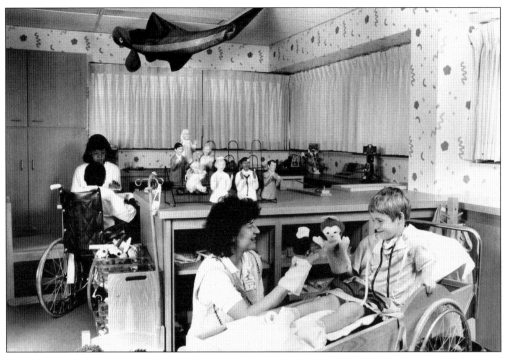

Therapeutic play helps children cope with questions and fears about being in the hospital. In these photographs, child life specialists use puppets and real medical equipment as tools to help children express themselves and learn.

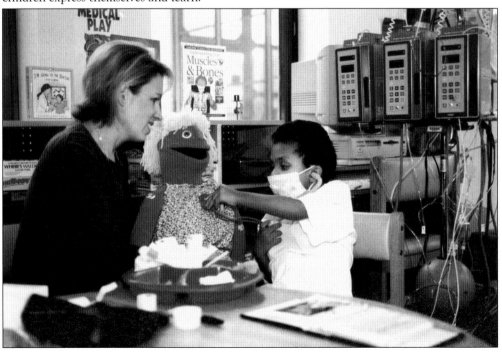

Participating in holiday celebrations helps children feel special. Valentine's Day 1989 was memorable for this child in the Convalescent Hospital for Children.

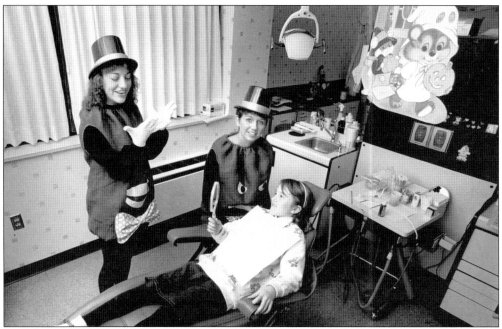

Children and employees enjoy Halloween at the hospital, when costumes and parties make the day a lot of fun for everyone. In this photograph from 1987 (above), the Department of Dentistry gets into the spirit of the holiday. Below, at the annual Halloween party in 1989, a mother and child giggle together.

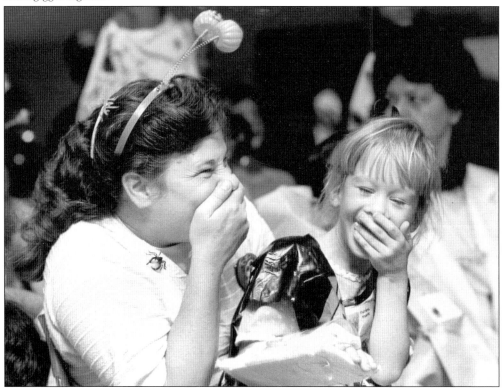

In 1939, Ruth Lyons , a pioneer radio and television broadcaster, asked her radio audience to send pennies, nickels, and dimes to buy Christmas presents for hospitalized children. She received $1,002. The next year, she raised $10,000 and established a fund for holiday and birthday gifts year round. The fund continues today, supplying toys, games, and crafts for daily activities, as well as gifts for special occasions. (Courtesy of WLWT-TV, Channel 5.)

When Ruth Lyons retired from broadcasting, Bob Braun took over as host of the 50/50 Club and carried on the legacy of the Ruth Lyons Children's Fund. In this picture from 1977, he makes his annual visit to Cincinnati Children's to light the Christmas tree.

Cincinnati Children's was founded as a ministry of the Episcopal church, and that history is still reflected in the Episcopal bishop's annual visit to bless the children at the Christmas chapel service. In this photograph from 1991, Chaplain Bill Scrivener (left), director of the Department of Pastoral Care, and Bishop Herbert Thompson Jr. preside over the service.

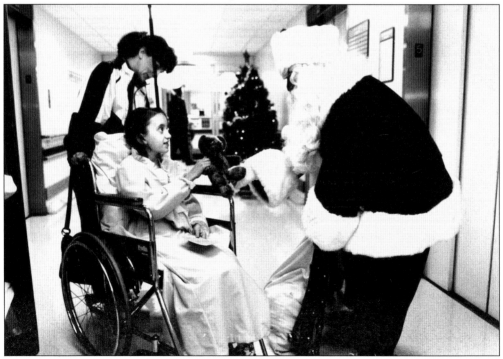

This gentleman, known only as the Mystery Santa, came annually bearing gifts for children of all ages. In this photograph from 1997, he is making his 37th annual anonymous visit.

It is obvious that this young girl loves the reindeer she received at the Ruth Lyons Children's Christmas party in 1992.

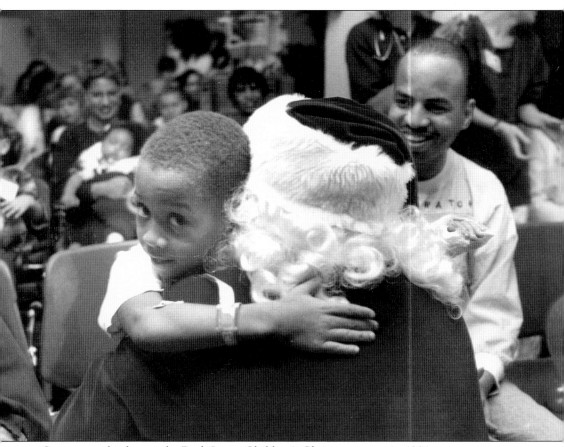

Santa gets a big hug at the Ruth Lyons Children's Christmas party in 1994.

Six

THE GENEROSITY
OF FRIENDS

The story of Cincinnati Children's is forever linked with the story of its friends and supporters. Contributors and volunteers across the community have always shared gifts of their hands and hearts, their time, money, and talents to support the hospital in its mission of improving the health of children.

The hospital's survival in its early years and its leap into national prominence in the 1920s would not have been possible without the remarkable generosity of the Emery family and William Cooper Procter. Yet all gifts were equally welcomed and needed.

When all care was provided without charge, all operating costs had to come from charitable gifts. The first benefit event was Donation Day, held January 1, 1884. Families across the Episcopal diocese showed up on a cold, wintry day with preserved food, flour, sugar, cereal, sheets, towels, blankets, credit slips for furniture, and nearly $3,000 in cash. Two weeks later, the ladies of the Cooperative Committee held their first meeting to plan continuing activities to support the hospital. Donation Day continued annually until 1970.

The Cooperative Society still exists and has been joined by countless philanthropic groups, individuals, businesses, and foundations. Their gifts, large and small, help Cincinnati Children's purchase state-of-the-art equipment, launch innovative research programs, and provide the highest quality, most family-centered care for children.

Other friends support Cincinnati Children's through volunteer service at the hospital. They cuddle, feed, and read to the children. They sew clothing, help with special events and office work, and perform countless tasks that are needed in the day-to-day functioning of a busy hospital.

Just as the community came together in 1884 at the birth of the new hospital, the community continues to come together today to help Cincinnati Children's grow and improve. In 2006, the first annual Cincinnati Walks for Kids attracted thousands to walk for a healthier future for children. Through their gifts, donors and volunteers are partners in making Cincinnati Children's the leader in improving child health. The photographs in this chapter provide just a glimpse of some of the many friends who have made a difference.

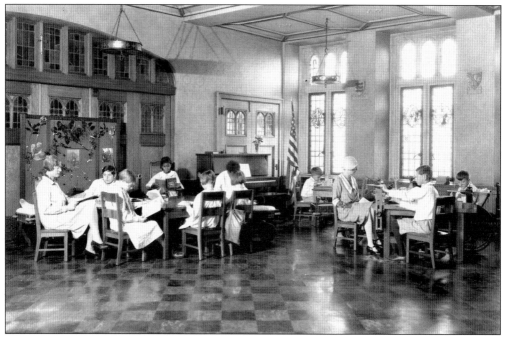

For many years, members of the Junior League volunteered at the hospital from October 1 to June 1. Other volunteers were recruited to help during the summer. Here Junior League volunteers read to children in the Stanley Matthews Memorial Schoolroom and Playroom.

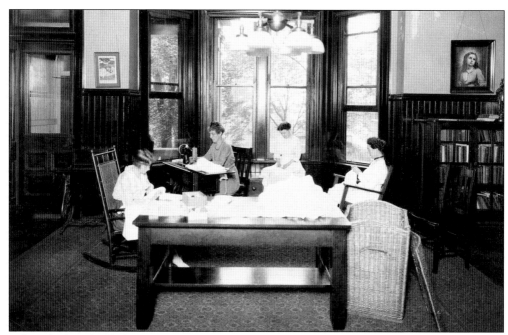

When the board of lady managers decided the hospital should provide clean clothing for all the children, a subcommittee of the Cooperative Society was formed to create sewing guilds. This photograph was taken in 1913. Volunteers today continue to sew garments, quilts, soft helmets for children with neurological disorders, toys, and customized dolls used as teaching tools.

After the success of the first Donation Day on January 1, 1884, the event was held annually, on the Thursday before Thanksgiving, until 1970. Above, the ladies gathered here are organizing the 1937 campaign. The beautiful woodwork and leaded-glass behind them was the entrance to the hospital's chapel. Below, donations included food, clothing, and other necessities, as well as money. All gifts, no matter the size, were recorded. Here three volunteers keep track of donated canned juice.

In 1952, the Cooperative Society opened a coffee shop and snack bar in the hospital. Initially the members did the cooking and serving. The coffee shop was renamed via a competition in 1980. The winning name, the Rainbow Room, was submitted by Marsha Barton, a waitress in the coffee shop.

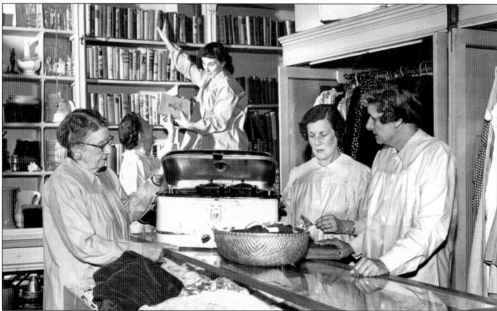

The Children's Hospital Thrift Shop opened in 1932. Located first in Northside and later at the corner of Twelfth and Walnut Streets in Over-the-Rhine, the shop sold clothing, china, glassware, costume jewelry, toys, books, and other items at bargain prices. Volunteers collected donated items and staffed the shop, with the dual purpose of raising money for the hospital while serving Cincinnati's poor. The shop closed in 1992.

The Association of Volunteers was established in 1964 as an auxiliary to raise funds for the Convalescent Hospital for Children, an affiliate of Cincinnati Children's. Officers elected at the meeting are (from left to right), Mrs. David Crawford, Mrs. Harry S. Robinson II, Mrs. Allan Lucht, and Mrs. Clifford Grulee. The auxiliary has sponsored the popular Cincinnati Antiques Festival every year since 1965.

The second auxiliary formed to support Cincinnati Children's was the Junior Co-Operative Society, established in 1910. The group operates the well-stocked gift shop at the hospital's Burnet Avenue campus. The shop's trademark item is its distinctive clowns, still handmade by auxiliary members. In this photograph from 1982, Mrs. A. Samuel Krebs (left) and Mrs. William Ventress admire one of the clowns.

Kindervelt, the medical center's largest auxiliary, is a neighborhood-based organization that offers women the opportunity to form strong friendships while raising funds for Cincinnati Children's. Above, this photograph from 1976 shows two of Kindervelt's founding members, Sharry Addison (left) and Barbara Fitch, talking with the hospital's administrative director James Turner. Both women are longtime members of the medical center's board of trustees. Founded in 1971, Kindervelt made its first gift in 1973. The amount of the annual gift is revealed each May. Below, in 1988, the gift was $427,000. As of May 2008, Kindervelt has contributed nearly $14 million to Cincinnati Children's.

James Ewell, seen here at the 1971 groundbreaking for the Pavilion Building (now Location E), joined the board of trustees in 1959. Through 44 years of service, he generously shared his wisdom, business savvy, and financial resources. As board president (1966–1978), he helped shape the future of pediatric care in the community. Later he took on a new leadership role, overseeing all major new construction projects from 1988 to 2003.

Kroger Pettengill and Barbara Robinson are seen here in the emergency suite dedicated in memory of their grandfather Barney Kroger. They are holding a photograph of the first Kroger delivery wagon. Both longtime trustees of the hospital, Pettengill chaired the campaign that raised $6 million in 1968 to finance new construction and served as chairman of the board (1979–1987). Robinson was one of the founding members of Kindervelt.

Volunteer Dick Sellins befriended this young boy, who spent his first four years in the hospital. Sellins built such a strong relationship that one of the child's first words was Dick's name. Sellins began volunteering at Cincinnati Children's in 1987. As of May 2008, he had given 12,888 hours of volunteer service.

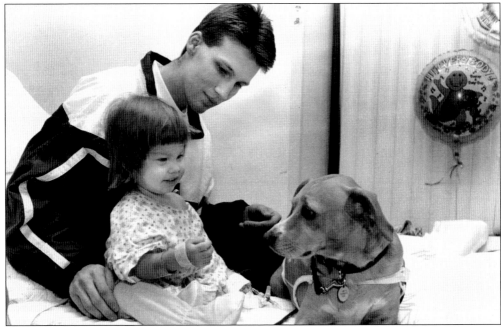

Scientist and dog lover Edith Markoff, Ph.D., established a dog visitation program in 1993. Here Dr. Markoff's pet Dusty visits Molly Hicks and her father on the first day of the program. Before visiting hospitalized children, dog volunteers must pass a behavioral examination and, with their handlers, go through extensive training.

Boomer and Cheryl Esiason, their son, Gunnar, and daughter, Sydney, attend the May 19, 1995, dedication of the Gunnar H. Esiason Cystic Fibrosis and Lung Center at Cincinnati Children's. The Esiason family and the Boomer Esiason Foundation are generous supporters of clinical programs at Cincinnati Children's to improve the quality of life for children with cystic fibrosis and of research to find a cure.

The birth of Emily Hayes inspired the Thomas family to become advocates for children with Down syndrome. Pictured here in April 1996 are (left to right) Sally Hayes holding Emily, Richard and Jane Thomas, and Bonnie Patterson, M.D., program director of the Jane and Richard Thomas Center for Down Syndrome. The center conducts research and offers comprehensive services for children and young adults with Down syndrome.

The Mayerson Center for Safe and Healthy Children, a unique program for diagnosing, treating, and prosecuting child abuse in a manner that minimizes trauma to the child, opened in 2001 with the generous support of the Manuel D. and Rhoda Mayerson Foundation. Seen here are (left to right) Patricia Myers, director, Division of Social Services; Neal and Donna Mayerson; Robert Shapiro, M.D., Division of Emergency Medicine; and Rhoda and Manuel Mayerson.

The Tennis Masters tournament is a highlight of summer in Cincinnati, and Cincinnati Children's is the beneficiary of the event. Since 1988, tournament gifts have supported the hospital's program for long-term survivors of cancer. Pictured here in 2001 are cancer survivor Kyle Perkins with (left to right) Richard and Carl Lindner, James Anderson, and Paul Flory. In 2008, gifts from the tournament topped $7 million.

In this photograph from October 1990, Debby Long (left) and Jean Wilson, both members of the Association of Volunteers, receive a card from 11-year-old Jermaine Wimpye, whose message could well be extended to all the volunteers and contributors who have supported the hospital throughout its history: "Thank you for caring."

Cincinnati Walks for Kids was launched on November 4, 2006, as an event to unify the community in raising funds for Cincinnati Children's. Undeterred by a surprisingly brisk morning, thousands of supporters, volunteers, employees, patients, families, and friends turned out to walk for a healthier future for children. In its first two years, the pledge walk raised over $1 million for the patients and families cared for by Cincinnati Children's.

Seven

A Vision for the Future

William Schubert, M.D., stepped down as chairman of the Department of Pediatrics in 1993 and as president and chief executive officer in 1996. His successors—Thomas Boat, M.D., leading the academic and research programs, and James Anderson, president and chief executive officer—inherited a strong medical center, well-respected locally and nationally. At a time when other U.S. hospitals were struggling, Cincinnati Children's was thriving and growing.

Anderson had been a member of the board of trustees since 1979 and chairman for four years (1992–1996). While chairman, he led the board through the process of defining a bold aspirational vision: "Our vision is to be the leader in improving child health." As chief executive officer, his challenge was to execute the vision. "I saw an institution ripe with opportunity to build on the talent and resources already in place," he comments. "My job was to release that potential."

Working with a supportive board, chaired by Lee Carter, and a committed leadership team, Anderson sparked an era defined by high aspirations, entrepreneurial spirit, investment in programmatic growth, and a determination to be the best at getting better—all backed by systematic, businesslike management and a strengthening infrastructure to deliver its bold promise.

Cincinnati Children's recruited renowned clinical and research leaders who introduced innovative programs. It built new facilities, in which the staff, armed with cutting-edge technology, could do its best work.

Beginning in 2001, Cincinnati Children's focused intensely on process and quality improvement to provide the best outcomes, experiences, and value for children and their families. This work catapulted Cincinnati Children's into greater national and international prominence. In 2006, it became the first children's hospital to win the prestigious Quest for Quality Prize, awarded by the American Hospital Association/McKesson Foundation. Cincinnati Children's also established a series of international and domestic partnerships, through which it is sharing its clinical expertise and knowledge of how to make transformational improvement.

Cincinnati Children's today is a growing billion-dollar-plus-a-year enterprise. Its patient care, research, and education programs are more comprehensive than ever before. This chapter introduces some of the people, facilities, and services that are making Cincinnati Children's the leader in improving child health.

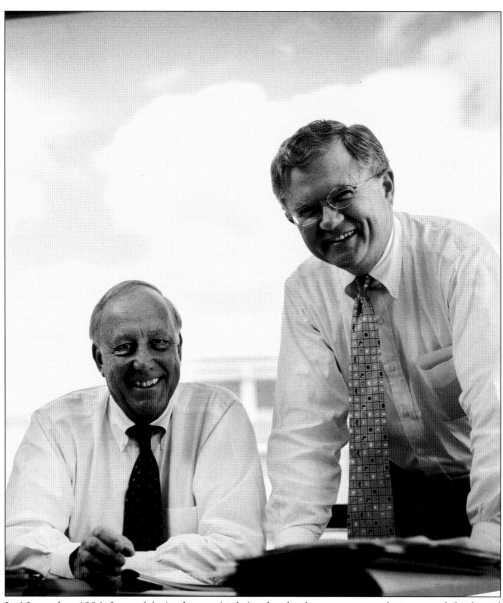

In November 1996, James M. Anderson (right), who for four years was chairman of the board of Cincinnati Children's, became president and chief executive officer, and longtime trustee Lee A. Carter (left) became chairman. They shared a willingness to support bold action to achieve the vision of being the leader in improving child health. Under their leadership, the medical center invested resources to support rapid programmatic growth and transformational quality improvement. Since 1996, Cincinnati Children's has dramatically expanded clinical, research, and education programs. It has achieved international recognition for promoting safety and quality, innovation, process improvement, and family-centered care. Today children in Greater Cincinnati have access to unprecedented health care services, and families around the world travel here when their children need highly specialized care. Carter stepped down as chairman in December 2007. He continues as a trustee.

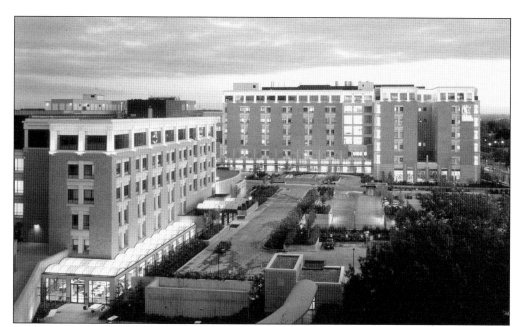

Cincinnati Children's embarked on an ambitious building expansion plan in 1998. Over the next four years, four buildings were added to the Burnet Campus. Two are pictured here: Sabin Education Center, also called Location D (left), opened in fall 2000, and Location A, a new hospital, opened in fall 2002. Not seen are an underground garage and an eight-story addition to the Location R research complex.

The 1926 hospital was demolished in 2004 to make way for a new research building, Location S, which opened in November 2007. This 415,000-square-foot building nearly doubled research space to more than 900,000 square feet, making Cincinnati Children's one of the largest pediatric research programs in the country. The investment in this facility reflects Cincinnati Children's commitment to scientific discovery to make a difference in the lives of children.

Neonatologist Uma Kotagal, M.B.B.S., M.Sc., pictured here in 1994, joined the faculty in 1977 and established the Division of Health Policy and Clinical Effectiveness in 1995. An advocate for evidence-based care, setting perfection goals, and measuring outcomes, she has been a catalyst for transformational improvement in quality. Under her leadership, Cincinnati Children's received the Robert Wood Johnson Foundation's Pursuing Perfection grant in 2002. Dr. Kotagal is now senior vice president for Quality and Transformation.

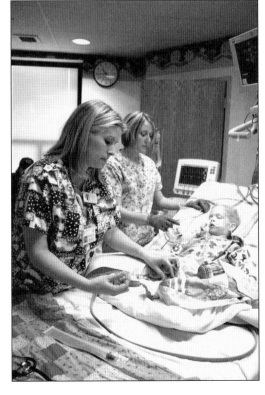

Ventilator-associated pneumonia (VAP) is one of the most common and dangerous hospital-acquired infections in intensive care units. In 2005, Cincinnati Children's launched an initiative to reduce the rate of VAP in the hospital's three intensive care units. By 2007, this successful improvement initiative had won local and national awards for achieving and sustaining a remarkable 89 percent reduction in incidents of VAP.

Richard Azizkhan, M.D., joined Cincinnati Children's in 1998 as surgeon-in-chief and director of the Division of General and Thoracic Surgery. A world authority in treating children with vascular anomalies, he established the Hemangioma and Vascular Malformation Center in 2000 and has been instrumental in creating other unique multidisciplinary services for complex conditions. Dr. Azizkhan is internationally recognized as a surgical educator and for his leadership in creating humanitarian and medical exchange programs.

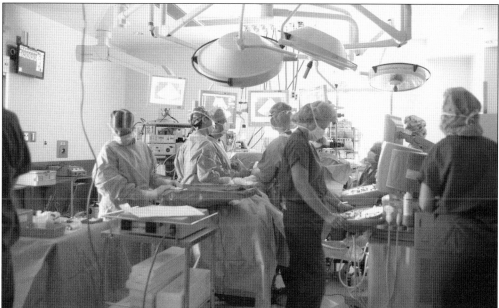

The Fetal Care Center of Cincinnati brings together the resources of three institutions to form the only comprehensive fetal center in the Midwest. The team includes experts in maternal/fetal care at University and Good Samaritan Hospitals, and leading-edge fetal/pediatric surgery and newborn care at Cincinnati Children's. The large fetal surgery operating room was built to accommodate two surgical teams, one for the baby and one for the mother.

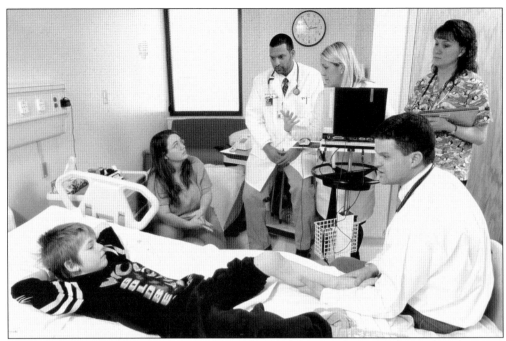

Cincinnati Children's has become a national model for family-centered rounds. The team approach improves communication by involving attending physicians, residents, nurses, other clinicians, and the patient's family. The process allows everyone to hear the same information, ask questions, and set goals together. Physician orders are entered into a computer at the bedside, improving safety and accuracy, and speeding the delivery of care.

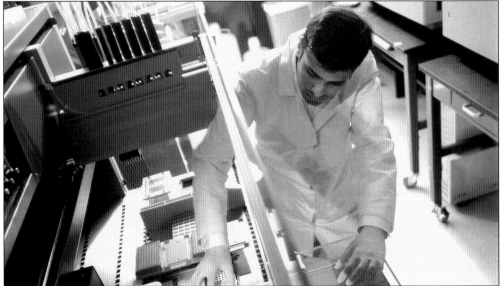

Investigators at Cincinnati Children's are on the leading edge of genetic and genomic research, bioinformatics, and personalized medicine. The medical center has established core facilities to enhance researchers' access to cutting-edge technology and sophisticated data analysis for a wide variety of projects. In this photograph, a robotic machine is used to prepare samples for testing with gene chip technology.

The Guest Services and Clinical Concierge programs assist the growing number of families from outside Greater Cincinnati who bring their children for care at Cincinnati Children's. Services include helping make travel plans, finding affordable lodging, scheduling multiple appointments, and arranging for language interpreters, if needed. On the day of the visit, a Guest Services representative meets the family and gives the child a small welcome gift. Here Lin Heald welcomes a family from Jackson, Mississippi.

Despite the community's growing need for psychosocial services, many psychiatric hospitals closed in the 1990s, resulting in a severe shortage of beds for psychiatric care. Cincinnati Children's and Convalescent Hospital for Children responded by purchasing the former Emerson North Hospital in College Hill in 2001 and opening a psychiatric hospital on the site in 2002. Today Cincinnati Children's operates one of the largest psychiatry clinical services programs in the country.

Cheryl Hoying, R.N., Ph.D. (center), joined Cincinnati Children's in 2006 as senior vice president of the Department of Patient Services, with responsibility for all nonmedical clinical services. She has launched initiatives to increase professionalism, recruit staff, improve the quality and safety of care, and achieve Magnet status for nursing. In 2008, she won the Prism Award from the American Organization of Nurse Executives for leadership in recruiting and retaining men in nursing.

With the northern suburban community growing rapidly, Cincinnati Children's announced plans in 2006 to build a new facility in Liberty Township. The Liberty Campus opened on August 11, 2008. It is the largest and most comprehensive of the eight Cincinnati Children's neighborhood locations, including eight operating rooms, a 24-hour emergency department, and 12 short-stay/observation beds, in addition to a large number of specialty clinics and laboratory, imaging, and therapy services.

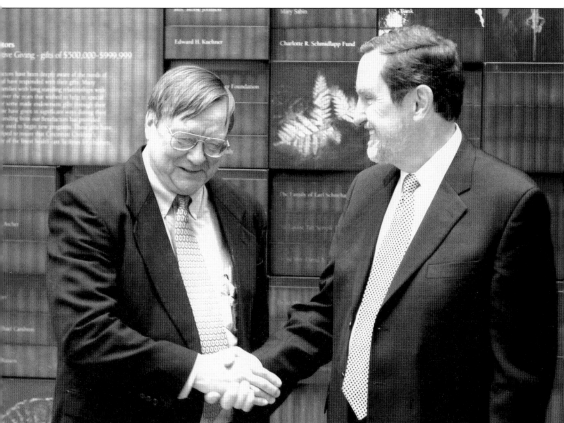

In May 2007, Thomas Boat, M.D. (right), chair of the Department of Pediatrics since 1993, passed the baton to his successor, Arnold Strauss, M.D. As the next B. K. Rachford Professor of Pediatrics, physician-in-chief, and director of the Cincinnati Children's Research Foundation, Dr. Strauss has taken on the challenge of moving Cincinnati Children's forward on the pathway to being the leader in improving child health.

ACROSS AMERICA, PEOPLE ARE DISCOVERING SOMETHING WONDERFUL. *THEIR HERITAGE.*

Arcadia Publishing is the leading local history publisher in the United States. With more than 3,000 titles in print and hundreds of new titles released every year, Arcadia has extensive specialized experience chronicling the history of communities and celebrating America's hidden stories, bringing to life the people, places, and events from the past. To discover the history of other communities across the nation, please visit:

www.arcadiapublishing.com

Customized search tools allow you to find regional history books about the town where you grew up, the cities where your friends and family live, the town where your parents met, or even that retirement spot you've been dreaming about.